Geraldine Mayo.

1887.

LADY MAYO'S GARDEN

The Diary of a Lost 19th Century Irish Garden

Kildare Bourke-Borrowes

Published by Double-Barrelled Books

Double-Barrelled Books
www. double-barrelled-books.com

Editor
Sian Parkhouse

Design
Alfonso Iacurci and Hannah Dossary
Cultureshock Media

Production Manager
Nicola Vanstone
Cultureshock Media

Printed By
Butler Tanner & Dennis Ltd

Kildare Bourke-Borrowes
March 2014
www.lady-mayo-garden.com

All text and illustrations are
copyright © Charles Bourke, Earl of
Mayo, except for the following, which
are reproduced by permissions of:

Lady Dunraven p29; Eva Morris pp7
52; Kildare Bourke-Borrowes pp6, 24,
28, 113 & 115; Sarah Bourke-Borrowes
p14; Royal Horticultural Society,
Lindley Library pp36, 37, 38, 39, 75

Paintings by Geraldine Mayo are
indicated as (GM) and those by
Gerald Ponsonby as (GP) in captions.

A CIP catalogue record for this book is
available from the British Library
ISBN: 978-0-9571500-8-9

LADY MAYO'S GARDEN

GARDEN

The Diary of a Lost 19th Century Irish Garden

Kildare Bourke-Borrowes

DOUBLE-BARRELLED
BOOKS

CONTENTS

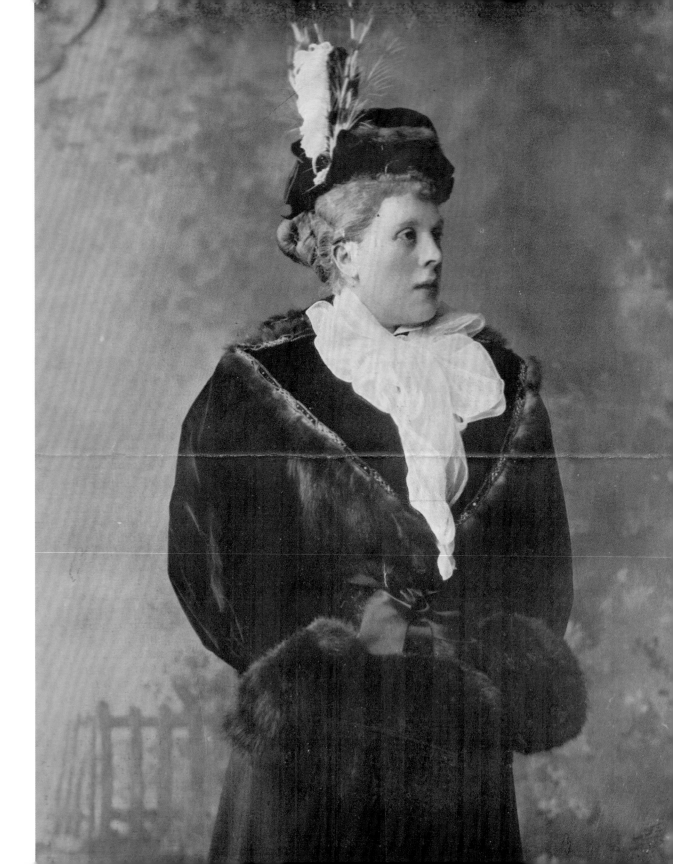

FOREWORD

It was a warm summer evening in the Gers, Armagnac country, and our family party was sitting looking at the setting sun reflected off the distant Pyrenees, a glass of cool white wine at hand. I was saying (probably yet again) how terrible it was that the devastating fire at our old home Palmerstown had robbed us of almost every family document and record when my cousin Sheelagh said "Well, have you seen this?", and gave me Geraldine Mayo's Garden Book, written 100 years ago, to look at. As a gardener myself, I knew immediately that this diary of a garden kept by her for 30 years was something very special, particularly as it was illustrated with meticulous and beautiful contemporary watercolours of the plants and the garden that she was describing in the pages of her book. In fact it was unique. It's rare to find this type of record because they tend to get discarded as fashions change; you only have to think of William Cresswell's miraculously saved diary of his employment as a journeyman gardener in the 1870s (found on a junk stall and now at Audley End), or The Heligan Head Gardener's work books saved from a solicitor's office, to realise how precious these things are. Almost miraculously Geraldine Mayo's Garden Book and her Travel Diaries survived the destruction of almost all her possessions in 1923, the sale of her homes and the scattering of her belongings after her death in 1944. These are the only things of hers which are still in the possession of her husband's family, they are very treasured

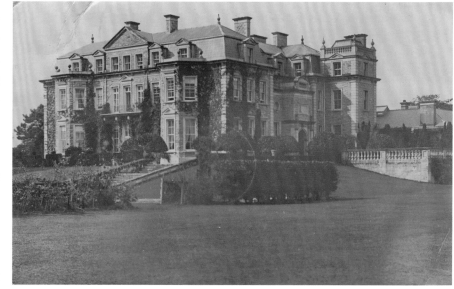

Palmerstown House

and without them we would know much less about her long, productive and eventful life. She wrote in her Garden Book foreword that she sincerely hoped *"that in the years to come it may be of interest to others."* In the much more constrained world that followed her life, it was probably viewed as a curiosity; few people were really interested in her sort of large high maintenance old-fashioned gardening – we had swept all that away. However in the last 20 years there has been a keen revival, a renaissance almost, of interest in that kind of garden, and the time has come when it is *"of interest to others"*. I knew at once that it needed a wider audience, and Double-Barrelled Books felt the same way and needed little persuasion to publish it. It adds, in a very personal and charming way, to our knowledge of

Geraldine, Countess of Mayo, 1896

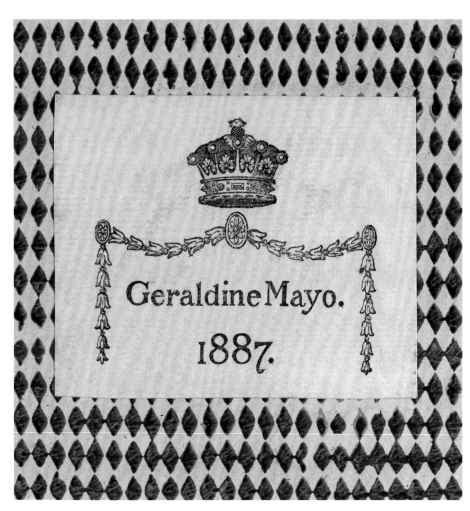

Garden Diary Bookplate - Geraldine Mayo, 1887

Victorian and Edwardian gardens in the British Isles – the period of their summit and early decline.

She wrote straight into her big book in pen, sometimes painting within the writing but more often sticking in or inserting her father's and her own delicate watercolours that were done on separate sheets. Her writing is usually quite easy to read, though a few words have proved to be indecipherable. Her plant nomenclature is imperfect, but I have chosen not to try to correct or amplify her text, except in a few cases and those are shown in *italics*. Many of the plant names she used have changed in the interim, and a few have no synonyms and are now obscure. Some of the varieties and cultivars she mentions have disappeared ('lost from cultivation'), as far as I know. I am not a professional horticulturalist (and nor was she), and I apologise in advance for any errors which may offend horticultural experts.

I am very grateful to Brian McCabe for much local information and guidance at Palmerstown itself, to Sir Charles Ponsonby for information about Gerald Ponsonby and that family, to Geraldine, Countess of Dunraven, for unlimited access to her family archive including about Palmerstown, to Anja Gohlke, Head Gardener at Kylemore Abbey for some interesting insights, and especially to Charles and Marie Bourke for their endless hospitality in Clifden, and their considerable assistance in making available the Garden Book, Geraldine's Travel Diaries and other material so that this book could see the light of day. Caroline Clifton-Mogg transcribed the whole of the original manuscript, a labour of love, and has been a wonderful & imaginative editor, and the team at Cultureshock Media have done an absolutely excellent job of making the whole book accessible and visually exciting.

INTRODUCTION

What happened in an Irish 'Big House' garden 100 years ago, who did what, what did it look like, where did the plants come from and how were they grown? These are interesting questions for anyone interested in social history or heritage or even just gardening itself, because these beautiful hidden-away worlds were where many thousands of people were employed, where much of the owners' resources – material and otherwise – were expended and where so much beauty and food were produced – in a way and on a scale that went into decline after the First World War and had almost disappeared by the Second. There were over 2,000 Big Houses in Ireland in 1919, many of them with walled gardens where all this activity was focused; by the 1990s times had changed so much that effectively all of them had fallen into neglect or been changed and diminished, and their records discarded or lost. However in recent years there has been a great revival of interest in heritage gardening, and both in Ireland and the UK some of these gardens have been rescued or revived, sometimes with astonishing success. We only have to look at Heligan in Cornwall, Kylemore Abbey in Connemara, Phoenix Park in Dublin, or Audley End in Essex to see what can be achieved. Much of our knowledge about these gardens has been gleaned from the few records that have survived, like this Garden Book, and using them to help work things out on the ground.

What Geraldine Mayo's Garden Book adds to this is that, as an owner, she actually kept a diary of the work and developments in her garden, and she and her father illustrated it with lovely watercolours. With these we get an unprecedented view of what was going on in the Palmerstown garden, what her plans were and what the garden looked like. The Book isn't a full compendium of each week in the gardening year, and there are inevitable omissions and gaps, but we forgive her these because she loved the place so much, she poured so much of her own energy into it and she really suffered, as all gardeners do, when things went against her – the awful weather, the flooded ground, the plants that died or did badly, the glass houses that collapsed.

Geraldine Ponsonby was born in 1863 at her parents' London house at 22 Upper Grosvenor Street; she married Dermot Bourke, 7th Earl of Mayo, in November 1885 in London, and came as the new bride to live at Palmerstown for Christmas that year; she was 22 and he 34. Her widowed mother-in-law moved out early in the New Year, and she was left in charge of the house, the household, the garden and much else besides.

Geraldine and Dermot Mayo –
engagement photo 1885

Palmerstown House itself had been built directly as a result of another terrible family tragedy, indeed a murder. Dermot's father Richard, the 6th Earl of Mayo, was appointed Viceroy of India in 1868. He left England that year and never returned, being assassinated by an escaped convict in the Andaman Islands, a penal colony. He was an extraordinarily capable, energetic and popular man, and on his death an Empire mourned. Among the very numerous tributes that poured in for months afterwards, a typical one from a contemporary was: *"Of all the Viceroys in my time the most popular, officially, socially, and in every way, was Lord Mayo. He was essentially a ruler, a man of commanding presence and outstanding ability, a lover of sport of all kinds, in short a Governor-General in every sense of the word"*. A very large public subscription was raised and Palmerstown House was built for his family as a Memorial from a grateful nation, replacing the old family home. It was a large comfortable house done in a late Victorian Queen Anne style, with 18 bedrooms (and one bathroom), all the usual kitchen, pantry, scullery, still room, larder, servants hall, stabling etc, with a 'museum wing' round the side that principally housed the Viceroy's archive and numerous memorabilia of his time in office. This new house had been built on a rise near the site of the old Georgian house, leaving down there yards of stabling, farm and estate buildings. Down there too, at a little distance, was the old walled garden, to which Geraldine was to devote so much energy. Two long drives led away from the house through paddocks and parkland, arriving at the little estate village of Johnstown, and the main Naas–Kill–Dublin road.

Geraldine was a disarmingly pretty slim blonde girl who had grown up in smart London, often a bridesmaid at Society weddings, often seen at the 'right' events and parties, especially during the Season. There was, though, a lot more to her than that. She was quite an accomplished cellist, she was knowledgeable about the arts, she was already a collector of glass, lace, needlework, ephemera etc, she was a devout Christian and she was a very accomplished watercolourist. In many of these things she had taken a lead from her father Gerald Ponsonby, and it's clear that he was the abiding influence on her life. Gerald Ponsonby (1829-1908), the youngest child of

the 4th Earl of Bessborough and his wife Lady Maria Fane, was born and brought up at Bessborough House, a fine old mansion in Kilkenny sitting on a very large estate. He was private secretary to his father when he was Lord Lieutenant of Ireland in 1846-47, and filled similar roles in England up to his marriage in 1858 to Lady Maria Coventry; thereafter he was immersed in the arts and theatrical worlds, in charities and in helping the poorest and most disadvantaged people in London. It was probably he who gave Geraldine this handsome volume of blank pages bound in vellum with GARDEN BOOK stamped in gold on the spine that she wrote and painted in for the next 32 years.

Lord and Lady Mayo led very busy lives from the moment they were married. There was of course a lot of hunting and field sports, there were numerous house parties, dinners and balls where all kinds of people were entertained – sportsmen, artists, bibliophiles, authors, politicians and relations – they went to many entertainments and events during the Dublin Season and rarely missed the London Season from June to August. They often visited friends and relations in Ireland and England, and they regularly went on foreign travels, for which she kept and illustrated interesting Travel Diaries. Dermot was a Representative Peer and was frequently away in Dublin and London, being very active in Irish affairs. On top of this they became very involved in the Arts & Crafts movement; they jointly founded the Irish Arts & Crafts Society in 1895, which held two major exhibitions. Geraldine herself was heavily committed to the Irish Industries Association, and she re-founded the Royal Irish School of Art Needlework, of which she was President (being herself a first-class needlewoman and rug-maker). Additionally she helped found and was a Director of the Naas Carpet Factory, and she was very active in nursing charities in Ireland and England. All of these activities, along with the need to let the house out for the summer season to balance their budget, meant that she could never devote as much time as she wanted to her garden, and rarely saw it in the height of summer – to her immense regret.

She and Dermot had no children, but she was immensely fond of her three nieces. After her death in 1944 it was written *"From her youth she had united a gracious personality with a wide range of culture and a keen love of outdoor amusements, a combination seldom found."* These qualities come out in her Garden Book. This book, then, is her legacy and we have rounded it out by including a number of the watercolours from her seven Travel Diaries (1887-1913).

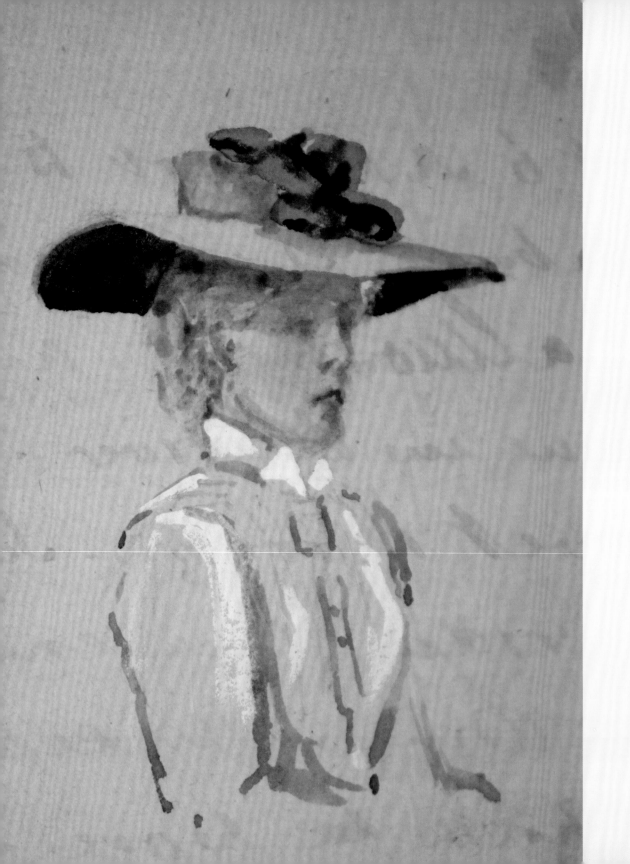

Self-portrait Geraldine Mayo 1887

PREFACE.

Preface page of the Garden Diary

I have had this book for nearly two years and have never had the courage to begin it, tho' I have known all the time that it would be a great pleasure to me, if once I could get over the obstacle of beginning something new!

Now, in January 1891, the beginning of a New Year, I make the effort, with the sincere hope that in years to come it may be of interest to others.

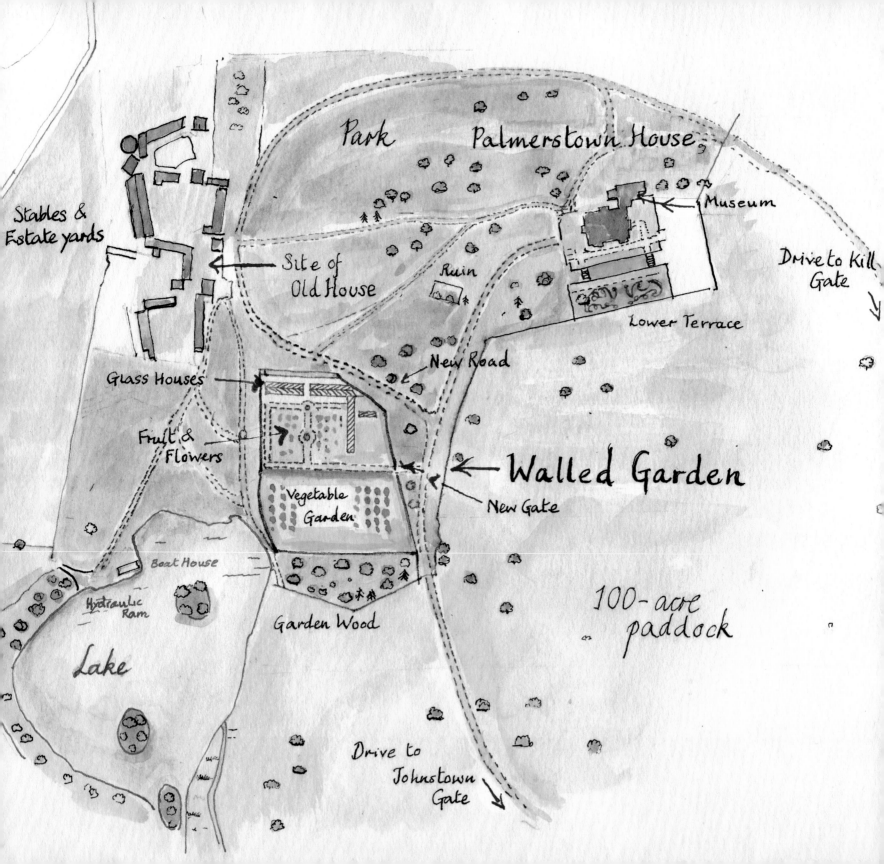

Park Palmerstown House

Stables &
Estate yards

Site of
Old House

Ruin

Museum

Drive to Kill
Gate

Lower Terrace

New Road

Glass Houses

Fruit &
Flowers

Walled Garden

New Gate

Vegetable
Garden

100-acre
paddock

Boat House

Hydraulic
Ram

Garden Wood

Lake

Drive to
Johnstown
Gate

It is 1891, and just over 5 years have passed since Geraldine came to Palmerstown, and they have been busy ones. She and Dermot were young, attractive, well-connected, well off and in demand – in Ireland and England. As newly-marrieds do, they had lots of people to stay, they visited old friends and made new ones, and they were very busy developing that range of artistic, political and charitable interests that would absorb them for the rest of their lives. Additionally in 1887 they went abroad for nearly five months from January to May, travelling to Italy and Sardinia, and again for another five month trip from December to May 1888 – to the South of France, Tunisia and Sardinia again. These trips were important because Geraldine kept travel diaries in which she records their daily lives, describes what they saw and did, and makes numerous paintings which became more and more confident and beautiful. In keeping the diaries she got into the habit of recording things both in writing and painting, and this no doubt gave her the confidence to start and elaborate her Garden Book.

When Geraldine arrived at Palmerstown, she had a problem. She was very young, she was away a lot, she knew almost nothing about gardening, and her Head Gardeners didn't take kindly to what they probably saw as interference from such a person when they knew exactly what they were doing. So she began by changing things just outside the garden walls and then she plunged in and had the entire herbaceous border moved from under the shade of the dividing yew hedge out into the open sunlight. She did other things too that were probably disapproved of. She ordered a range of herbac eous plants and bulbs from a nursery catalogue (mostly tall and very conspicuous), which had probably never happened previously, and then she herself got on a ladder and did the initial shape-trimming of the young yews she had had planted 3 years previously – certainly no Lady Mayo had ever done that before. These were definite signs of what things would now be like.

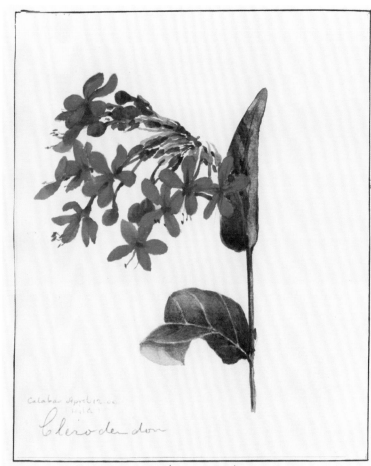

Clerodendron, West Africa 1909 (GM)

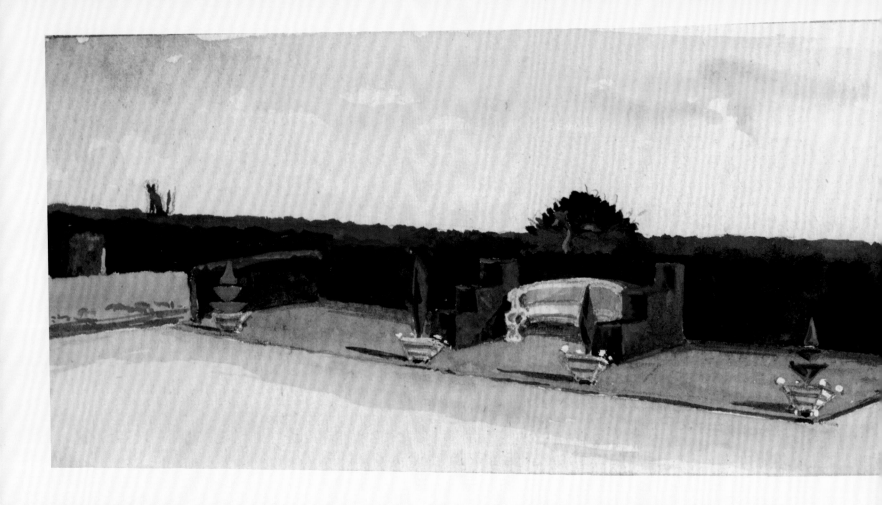

Preamble

I must go back a little and explain what we have done in the garden.

First – outside: in 1887 we made the walk under the Yew trees on the West side of the Garden wall, by cutting away the branches which reached almost to the ground. In 1889 we made the walk called 'The Pergola', using the willows etc. that were being cut down by the lake, for the structure, and the creepers that were already on the wall for covering. As well as planting others. The gate at the top was given to Dermot by his mother some time ago, and came in beautifully here. (*Later entry* – This was removed to the Terrace at the House). Inside: in 1888 I removed the Herbaceous border from under the North side of the Yew Hedge, where it did not flourish owing to the lack of sun and to the enormous roots of the Yew, to where it is now, and planted grass seed from Sutton's, and 10 young yew trees, hoping that someday it will look like this [above]..

In August 1889 H Burgess, gardener and Steward, went away and was succeeded by Russell, sent away in Sep 1890. In Oct: 1890, Fulford came who is here at this moment.

The garden has suffered from these changes. In Oct: 1890, I planted the following, making the new borders, bought from Thomas Ware, at Hale Nurseries, Tottenham.

~ 12 St Bruno's lily [*Paradisea liliastrum*]
~ 24 big orange etc Poppies
~ 12 Day lilies [*Dumortieri (sp) and Flava*]
~ 24 Pyrethrums
~ 24 Lilium pyrenaicum [*sp*]
~ 7 Peonies
~ 42 Iris
~ 320 Sparaxis
~ 2 Delphiniums
~ 12 white Everlasting Peas
~ 12 green Tulips, etc, etc.

The whole coming to £17-8-10.

In 1890 we planted the following apples and pears.

Apples
~ Alfriston
~ Blenheim Orange
~ Cox's Orange Pippin
~ Dumeller's Seedling
~ East Lothian [*Pippin*] Seedling
~ Ecklinville
~ Lane's Prince Albert
~ Stirling Castle

Pears
~ Marie Louise
~ Beurré Diel.

Sep 28th 1891

The Countess of Mayo

Bought of J. C. TONKIN,
GROCER AND PROVISION DEALER,
❦ FLORIST ❦ AND ❦ BULB ❦ MERCHANT. ❦
CUT FLOWERS January to June. Boxes 2/6 to 21/-

		s	d
100	Soleil d'or Narcisse	8	0
" 100	Scilly White "	7	0
" 100	Belle of Normandy	7	0
" 100	Glorieuse	8	0
" 100	Odorus Campernellie	7	0
" 100	Mixed Narcissus	7	0
100	Single Grandiflora	4	0
		7	0
		5	0
		5	0
		4	6
		3	14
100	Soleil D'or	2	6

The Countess of Mayo Aug 31/91
To J. Jackson

1891

Several significant things happened in this year concerning the garden and the house. She took on her 4th Head Gardener in 2 years; we don't really know what was behind all this – Geraldine was a very nice, loyal and forgiving employer, and many of her household staff stayed with her for a very long time, but it's clear she had high standards, and she was now beginning to understand about the garden and what she wanted done. Equally significantly, Dermot and Geraldine decided to let out Palmerstown for the summer season, something that they continued to do on and off for many years. Unless you were very rich, letting out your house in the summer was not unusual, there was a ready market, and the income from the two to three months helped fill a hole in their finances – they weren't nearly as well off as they appeared to be; they could have let it out in the winter also for the hunting season, but chose not to. What it meant was that year after year Geraldine missed most of her garden's summer glory. The other significant event of the late summer of 1891 was that, after the London Season, they went all the way to the Scilly Isles to stay at Tresco Abbey with Algernon Dorrien-Smith, a renowned gardener and spring flower specialist, and an old friend of Dermot's. From him Geraldine acquired her lifelong enthusiasm for spring bulbs, and she now ordered her first 1,800 bulbs. There would be many subsequent purchases, and often she planted these bulbs out herself – a tedious job as anyone who's done it knows. The last significant event of this year was that in November she had the first of many disasters with her greenhouses (which she calls the 'houses'), that were and still are such an essential feature of ambitious gardens, large and small.

February — Very fine and very sunny but with 3º and 4º of frost most nights – which is very trying to the flowers. The Parma Violets [*fragrant cultivars of Viola alba*] are quite lovely, especially the white ones, which I got last spring from Bessborough[1]. I went to see Mr Eddie Moore's garden, which is a very nice one, tho' principally herbaceous, and so not so very much to look at now, but his Parma Violets are quite splendid – the great secret is to get them as near the glass as possible. He gave me some bulbs of a white Daffodil, of Scillas and of two other herbaceous plants

March 3rd — The Orange tree is in full flower and smells too delicious, also two very good white Azaleas are all in the drawing room. The first Lent Lilies are out and we have picked a few Primroses. **March 8th** — 23º of frost last night and the hills quite covered with snow. Fulford went away and John Shute came this month.

April — Very cold and windy but with a bright sun. The Niphetos Rose in the greenhouse was one mass of bloom and also the big white Azalea that I bought for £2 from Mrs Manders.

May 1st — Planted in the border by the house a Daphne fioniana and in the Museum Border a Hibiscus syriacus, given me by my mother. Lovely spring weather at last. The Primroses all in full flower - we have planted a great many by the pine tree on the Terrace. **May 2nd** — I got on to the top of the Yew hedge in the garden at the risk of my life and cut out the Cat[2] - the first clipping it has had. It looks quite like a cat, tho' it is still rather weak about the head.

Invoice for Scilly spring bulbs 1891

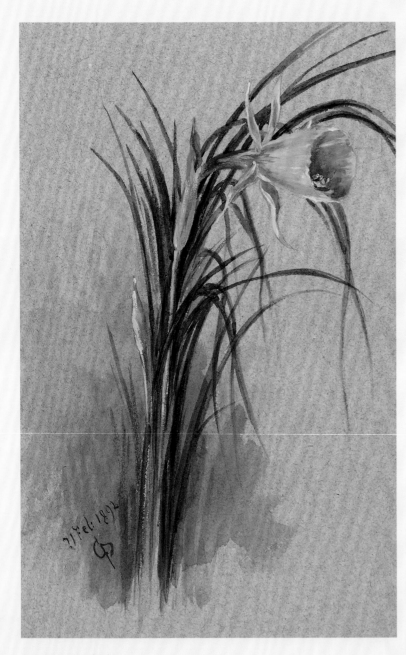

Narcissus 1892 (GP)

Autumn — We let Palmerstown to Lord Ashbourne from July 1st to Sept 15th – and we spent the Autumn, first at Scilly with Mr Dorrien Smith[3] and then at Doochary[4]. I came back on Sept 20th and found the herbaceous border looking lovely and very bright. I bought all the following bulbs and planted them myself which was very hard work.

Mr Dorrien Smith gave me
~ 24 [*Narcissus*] Poeticus recurvus
~ 18 Poeticus ornatus
~ 2 C.J. Backhouse
~ 12 [*Amadeus*] Mozart orientalis
~ 18 Grand Monarche
~ 12 Ajax
~ 20 Schizanthes
~ 6 Sulphur Kroon
~ 12 Stella
~ 15 Scilly White
~ 3 Empress [*of Ireland*]
~ 3 Emperor
~ 6 Amabilis Leedsii
~ 18 Gloriosus
~ 9 Sir Watkin
~ 18 Soleil d'Or
~ 18 Single Incomp [*arabilis*]
~ 18 Cynosure
~ 12 [*Pseudonarcissus*] Obvallaris
~ 12 Orange Phoenix
~ 2 Barrii Conspicuous, besides Jersey Lilies [*Amaryllis belladonna*] and Freesias. My father sent me common daffodils which I have planted on the Terrace.

Invoice for garden bulbs from Holland 1891

BULBS

LEGOM
near
AARLEM
HOLLAND.

VAN MEERBEEK & Co.

URSERIES.

TRADE MARK.

No

REGISTERED.

Every parcel of Bulbs bears our Trade-mark.

Hillegom, near Haarlem, Aug 31st 1891
(HOLLAND.)

INVOICE for *The Rt Honble the Countess of Mayo*
Straffan from **VAN MEERBEEK & Co.**

One Box marked:

VAN MEERBEEK & Co.
FLORISTS
HILLEGOM, HOLLAND.

No 81 containing:

antities	NAMES	Prices	
100	Parrot Tulips mixed	£	5 -
100	Breeders "		5 -
100	Double Jonquils		9 -
100	Single "		3 6
100	Double Anemones mixed all colours		3 6
100	Single " " " "		2

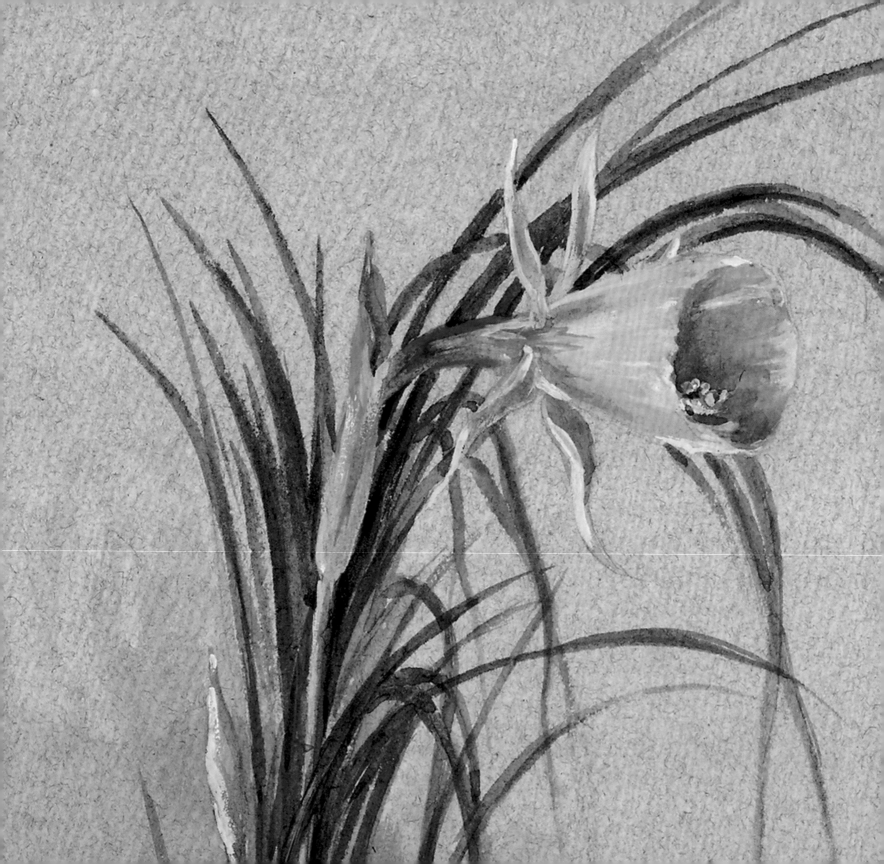

October 24th — The first severe frost came and killed all the Dahlias and tender things in the herbaceous border. Mr John Olphert has sent me 3 lots of herbaceous plants all of which I have put in the border. The Greenhouse Rhododendron, Princess Royal, is one mass of bloom. In November the brick flue in the hothouse burst and burnt up most of the Carnations and foliage plants to our despair. We settled then, never to have a brick flue again but to take the pipes from the vineries (which are never heated now) and to put them into the two houses. This, a man called Cockburn said he could do in a week – and we foolishly believed him! On **Feb 1st**, he had not yet done them! So we sent him away and got Morison to finish the job. In the meantime the two Stephanotis had died and various other plants, so we have had a very bad time. The Orange tree has 33 oranges on it.

Canary Islands 1909 (GM)

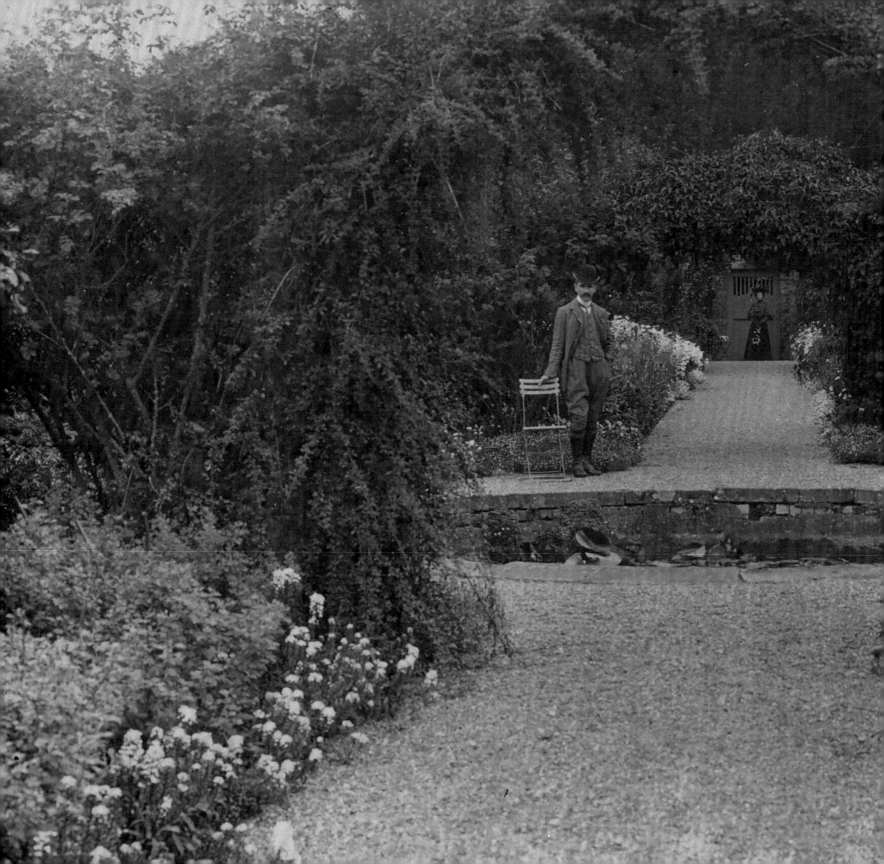

Walled Gardens

This book is about an old walled garden. They, or the remains of them, are everywhere on the mainlands of Britain and Ireland; big houses generally had large ones while smaller establishments like rectories, manor houses, villas, etc, had smaller ones. Enter such a garden and you go into a special and apart world – sheltered, warm, industrious, quiet and orderly. The protecting trees look over the walls into the little paradise like waving patriarchs; a productive walled garden is a horticultural paradise, and that's just what the Persians who first had them thought, though theirs were built for shade and tinkling water in a parched land.

Many walled gardens of large and grand places were situated quite far away from the house, where they wouldn't interrupt the views of the landscape or offend their owners' sensibilities with their smells and noise. However, having the garden near the house had its advantages too. Delivery of the carefully washed, ordered and wrapped produce to the back doors was much easier, as was the delivery to the garden of cartloads of manure from the stables and the home farm dairy.

The greatest area and the greatest effort in most walled garden was devoted to growing high quality vegetables and fruit, which were needed continually to feed the household, indoor and outdoor staff as well as the farm and estate workers. Even in a quite small establishment like Palmerstown these numbered at least thirty people, and this could rise to forty when there were house parties and entertainments. All the traditional staples were grown – potatoes, carrots, cabbages, cauliflowers, turnips, onions, leeks, beets, radishes, pumpkins, marrows – and these were joined by many newer or seasonal crops such as lettuces, tomatoes, beans, etc. Apples tended to be grown on free-standing espaliers, pyramids or cordons, cherries and plums on trees, berries, gooseberries and currants in squares, while tenderer soft fruit such as peaches were grown on sunny wall espaliers, as were pears, sometimes in little sun-catching alcoves in the wall as at Palmerstown. Many techniques were employed to extend the ripening seasons of all this produce, both in the growing and the storing in the 'back sheds', or even in the ice house where there was one.

Glasshouses of every sort were commonplace by the 1850s, and in most ordinary walled gardens were constructed along the south-facing wall, and when that was full the west facing wall was used too. Among their numerous uses were the abilities to force early flowering plants, grow out-of-season and even exotic fruit, over-winter tender plants, grow and keep exotics, and plant and protect seedlings

from cold, birds and animals. There was a variety of heating arrangements, and the houses were separated into different temperature zones from very hot to cool. Additionally there were forcing pits heated by fresh manure, which were usually free-standing. Huge amounts of manpower went into the heating of these houses day and night, and their continual maintenance (*see pages 95–97 Glass Houses*).

There was also an entire working area in the shady (often cold) space behind the glass houses but still within the walls – the backsheds. The centre of this was the bothy, a small building of usually a few rooms with a fireplace, where the gardeners gathered, rested, ate, and where the junior gardeners slept; nearby was the Head Gardener's office. A below-ground boiler needed tending day and night, and above ground there would be a potting shed with a pot washing area, an area for washing, trimming and packing the produce, cool dark storage areas to preserve fruit and vegetables in various ways, tool storage and maintenance, etc. This quite large area of 'sheds' in the back area of grander gardens was a hive of activity and contained every sort of sophisticated environment for forcing, preserving and extending the life of everything that was grown, so that the House could enjoy hugely out-of-season fruit and veg; there was often a mushroom-growing house too. The Head Gardener had to keep in close contact with the housekeeper and the cook to anticipate all the culinary needs for the house parties, dinners, lunches, balls and other entertainments. There was, after all, absolutely no popping down to the shops if you ran out of rhubarb on the day.

Additional to all this growing, preparing and supplying of vegetables and fruit through the year, there were the flower beds which grew in importance as the fashion for bringing cut flowers into the house caught hold.

The lot and roles of the skilled garden staff are often overlooked. The Head Gardener towards the end of the 19th century was paid about 22 shillings a week, and was given a house, coal and vegetables. Foremen were paid a little less, and got a small house or bothy with coal and light (oil lamps, candles, etc), while standard journeymen (or under-) gardeners got about 16 shillings a week with some benefits. Below them were the apprentices who might live at home locally and walk up to work and often a pot boy who cleaned the hundreds of pots and a dipping boy who collected water from the central dipping pond; at busy times these people could also be joined by labourers who worked on the wider estate. All these men worked a 10-hour day, often 6 days a week, with only a few holiday days off. It was hard work in all weathers and journeymen

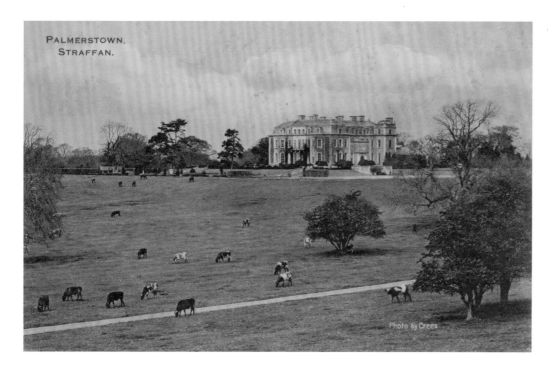

PALMERSTOWN.
STRAFFAN.

Photo by Crees

gardeners often moved on in search of better pay and conditions. Eventually, if they could, they set up as small nurserymen and seedsmen. A small place like Palmerstown employed 5 or 6 men; larger houses employed dozens of gardeners. The revival in interest in old gardens, and gardening in general, has brought about the enhancement of status of professional gardeners and the respect in which they are held; they are at last being valued as the experts that they truly are.

The 4 acre (1.6 hectares) walled garden at Palmerstown was probably made in the first half of the 18th century by John Bourke, 1st Earl of Mayo, whose continuously growing family and staff needed food and lots of it. It was built quite close to the old house, where the ground was flat and sheltered and because that was where the outlet from the lake ran; a productive walled garden needs lots of water. The surrounding envelope of trees and shrubs made it nearly invisible, and a lower lane allowed all the comings and goings between the garden and the yards at the back of the house to go on unseen. The garden in the 18th and early 19th centuries was a single large open space, divided in the age-old way into its four 'quarters' with paths radiating from a

central lozenge, in which there was probably a small pond; its high walls were built of stone. When Geraldine Mayo arrived in 1886 the garden was divided into two parts. The southern half was devoted to vegetables, and was an area into which ladies rarely went. It was separated from the northern half by a thick yew hedge, and in here were then grown cutting flowers, fruit and young trees. Glass houses along the north wall (facing south) and protruding out parallel to the east wall (facing west) produced fruit and flowering pot plants for the house. The Head Gardener knew his job and, in the frequent absences of the owners, got on with directing the work season after season needing no instruction and little direction. All this was quite normal, as was the absence of garden around the house itself, apart from a few mostly shrub-filled beds; for women like Geraldine if you had a walled garden, that was The Garden – everything else was park, woods and estate.

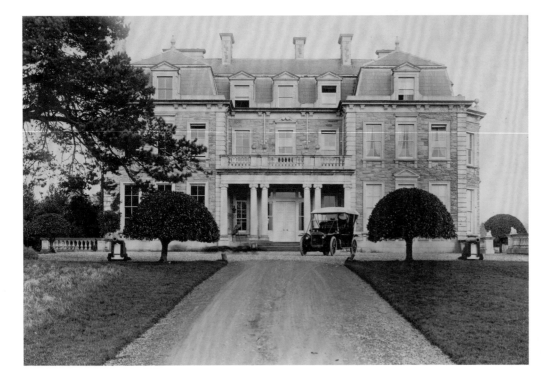

Palmerstown House entrance front 1910.

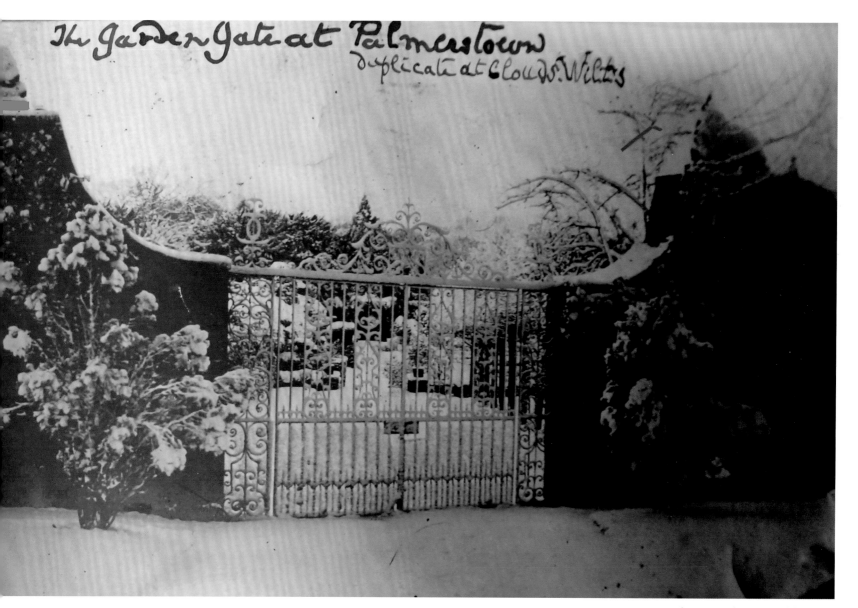

The new Garden Gate with lions and the two yews planted by Geraldine in 1898, given by her father

Degrees of Frost

Geraldine frequently refers to cold temperatures in terms of 'degrees of frost', a very common term then but which is hardly used today. It simply means the number of degrees below freezing point, which is 32° on the Fahrenheit scale that she used. So for example if the thermometer registered 28° F that would be 4° of frost; if it registered 22° F, which would be 10° of frost.

To convert these temperatures to Centigrade or Celsius, for a quick rule of thumb, subtract 32 from the Fahrenheit temperature, then divide by 2.

For an exact conversion, subtract 32 from the Fahrenheit temperature, multiply by 5 and divide by 9. So to convert 28° F, subtract 32 = -4, multiply by 5 = -20, divide by 9 = -2.22°C.

Wildlflower Lapland 1893 (GM)

1892

We feel in the diary this year that Geraldine's gardening confidence is gathering pace. People have heard of her enthusiasm and are starting to give her plants. At this stage too, knowing that she would often be away in the summer, she focused her energies on spring bulbs, and bought and planted over 6,700 of them, including 2,000 from Turkey, which seems rather adventurous. It's now clear also that her father shared her gathering enthusiasm for plants and gardens, was often at Palmerstown, advised her from early on and went with her on garden visits in England.

Narcissus 'Gloriosus' 1892 (GP)

Jan 26th — I picked the first Snowdrops in the garden. Those in the grass near the house are only just coming up. The Narcissus from Scilly are doing so well. I have great pots of 'Scilly White', 'Gloriosus' and 'Soleil d'Or' in the room. The Hyacinths are not quite so good this year.

Feb 13th — Lady Constance Leslie gave me a Stephanotis, a Bougainvillea, Plumbago and Eucalyptus – all such nice plants. The Hellebore 'Apple Blossom' [*a variety of Helleborus Niger, probably lost*] that Ware gave me in December has flowered a little. The Boronia [*a genus of evergreen flowering shrubs*] that Lady Mayo[5] gave me is covered with buds.

April — Such a fine month – very hot at the beginning and then cold about Easter, with snow and frost and then warmer again. The Daffodils from Scilly have been quite lovely. The first to come out were Rugilobus, Scoticus, and Stella. Then came my Horsfieldii, Bicolour, Emperor, Tazettas and Empress, then C.J. Backhouse, Orange Phoenix, Sulphur Kroon and finally the Poeticas, and Belle of Normandy and Scilly White, quite late – in fact in the middle of

May — I planted a Daphne mezereum and a white one in the garden – also some [*Anemone*] hepaticas, different colours – 2 Acanthus and a few other herbaceous things.

May 14th — Quite hot, like Summer – I planted 200 bulbs of 'Maximus N' [*Narcissus hispanicus maximus*] and 100 of a white daffodil I got from Cork[6]. We went to see the ruined house at Rathcoffey[7] and there found a great many 'N. biflorus' growing in a field. I also found an enormous quantity of these growing in a field on Nugent's farm at Sillart Hill. There were also 'Butter & Eggs' [*Linaria vulgaris = Common Toadflax*] and a common Daffodil with some 'Incomparabilis' – a most lovely sight.

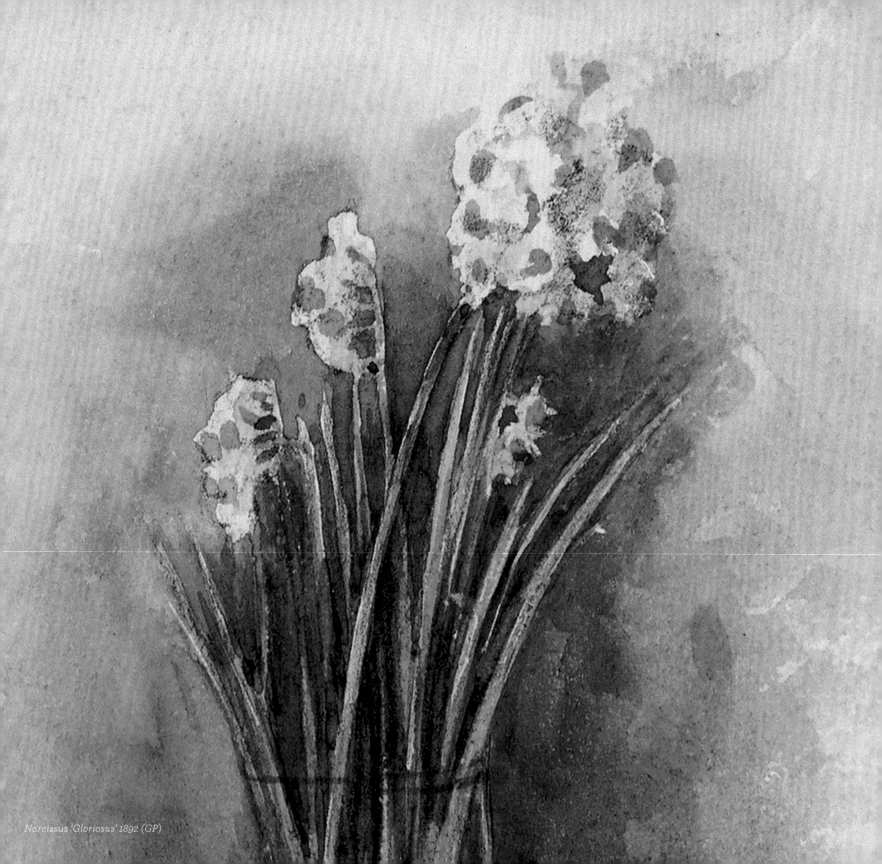

Narcissus 'Gloriosus' 1892 (GP)

Carpathace

We left Palmerstown for London on **May 23rd.** My father and I went to stay at Bulwick Park, Wansford, with Miminie Grosvenor. Such a lovely place with a charming garden, most splendidly managed. She had a long straight bed, of different Iris, with great clumps of orange Lilies down the middle – a glorious sight. We went to see Lord Exeter's place – Burleigh , and Lord Westmorland's – Apethorpe, and also Rockingham Castle. The gardens at the two latter places were perfect, old-fashioned gardens with, at Rockingham, a great deal of clipped yew. The way the bees were placed at Apethorpe was most picturesque – the high hedge behind was of Yew and the little arbour of Lime.

At Burleigh, all the energies of the gardener are devoted to vegetables and the wonders he works are almost incredible but it is not so interesting to the uninitiated! I had flowers sent to me to London[8] – some good Irises and Delphiniums and a lot of bad Roses – I ought to improve the Roses here. I returned to Palmerstown on **August 12th** and found things very much gone to leaf, as there has been a frightful lot of rain. The Carnations are good – but nearly over – excepting the Duke of Wellington, which won't be out for another three weeks.

Galanthus 'Carpathace' (GM)

Jew. & the little arbours of lime – At

Burleigh,
the energie
the garden
are devoted
vegetables
the wonder
works are
almost me
but it is m
So interestin
the ministra

had flowers sent me to
ndon – some good irises, &
phiniums & a lot of bad
es – Sought to improve
Roses here –

September 3rd — Dreadful showers and gales of wind – despairing to the gardener. I bought today from Protheroe and Morris 180 Hyacinths for forcing and 2050 Crocuses for the borders.

In October were planted the following:

From Tonkin – Scilly		From Jackson - Scilly	
~ 100	Gloriosus	~ 300	Soleil d'Or
~ 100	Golden Mary	~ 100	Scilly White
~ 300	Golden Phoenix	~ 200	Gloriosus
~ 200	Odorus Campernelli	~ 72	Mozart Orientalis
~ 100	June Supreme	~ 72	Leedsii
~ 100	Orange Phoenix		
~ 50	Sulphur Kroon	From Walker – Ham	
~ 100	La Candeur Tulip	~ 100	Golden Eagle Tulips
~ 100	Duc van Thol Tulip	~ 100	La Candeur (*Tulips*)
		~ 200	Gesneriana (*Tulips*)
From Franz Schlosser, Smyrna[9]		~ 100	Irish Mont Blanc
~ 1000	Scilla bifolia	~ 100	Mixed Iris germanica
~ 1000	Chionodoxa luciliae		

In all 6724 bulbs.

On **17th October** we had a good hard frost which killed the Dahlias and Begonias. On **18th Oct**, the last coat of paint was put on the new iron gates by the pergola – before we had wooden gates painted white – these iron gates were originally in front of the Old Parliament Houses in Dublin and were taken away by Kenan of Fishamble St, Dublin when he made and put up new ones. We bought them from him for £8 for the two gates. Corcoran, builder etc, Naas, set them and also built the red brick wall and piers – the brick came from Lord Annaly's new brick field at Lucan.

October 31st — I planted 260 daffodils, sent me by Mr Smith Dorrien, in the new beds round the little pond in the garden.

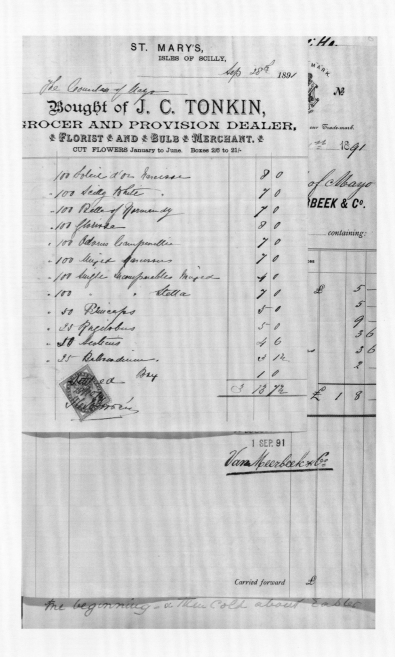

SPRING 1894

Wm Cutbush & Son

HIGHGATE LONDON AND BARNET HERTS

Descriptive Catalogue of Flower Vegetable Farm Seeds &c

Nursery catalogues of 1894 and 1868

Old Nursery Catalogues

Geraldine bought plants from quite a number of plant nursery catalogues (Thomas Ware of Tottenham, Protheroe and Morris of Leytonstone, Tonkins and Jacksons of Scilly Isles, Riverslea of Purewell, Kelways of Langport, Veitch of Chelsea[10] among others) as well as, on at least one occasion, from the catalogue of the famous Army & Navy Stores in London. It is natural to think that such catalogues were a 20th century development, but they are much older than that. Simple plant lists were first printed by a few English nurserymen towards the end of the 17th century, and grew in popularity and size during the 18th, especially among seedsmen. Every decade or so they became more sophisticated with plate illustrations, then plant descriptions and then price lists, with business and competition spurred on by the explosion of interest in gardening at many levels of society, the establishment of the railway network and then the Parcel Post in 1883, which meant that delivery could be fast and at a fixed price, and by the continual improvements in printing techniques. By the 1860s illustrated annual seed and plant catalogues were both numerous and easily available and, like today, anyone who could afford them could buy and grow the plants that they admired in public gardens and parks or in the gardens of private houses that they visited. The introduction of colour before the First World War led directly to the catalogues that plop through our letter boxes today, and help us dream of summer glories.

Old plant and seed catalogues are of huge interest to garden historians. They indicate when new plants were introduced, especially imported exotics, the dates of the appearance and disappearance of popular cultivars, what was fashionable and in demand in any period and are a vital checklist on the uses of botanical names.

SPRING 1868.

BRUNSWICK NURSERY.

A DESCRIPTIVE

CATALOGUE

OF NEW AND OTHER

Chrysanthemums, Dahlias,

TROPÆOLUMS,

FUCHSIAS, GERANIUMS,

AND MISCELLANEOUS

BEDDING PLANTS,

CULTIVATED FOR SALE BY

ADAM FORSYTH,

STOKE NEWINGTON, LONDON, N.

London:
PRINTED BY COLLINS AND HEARN,
5, CHURCH STREET, STOKE NEWINGTON.

1899

DICKSONS

SELECT
Vegetable and Flower
SEEDS

SEED POTATOS.

Garden Tools &
all Garden Requisites.

By Special Warrants to H.M. The QUEEN

And to H.R.H. The PRINCE of WALES

| DICKSONS | SEED GROWERS NURSERYMEN &c |

Chester.

Address for Letters, Telegrams, &c.,
"DICKSONS, CHESTER".

National Telephone Nº 43.

Late 19th-century
nursery catalogues

IRIS KAEMPFERI

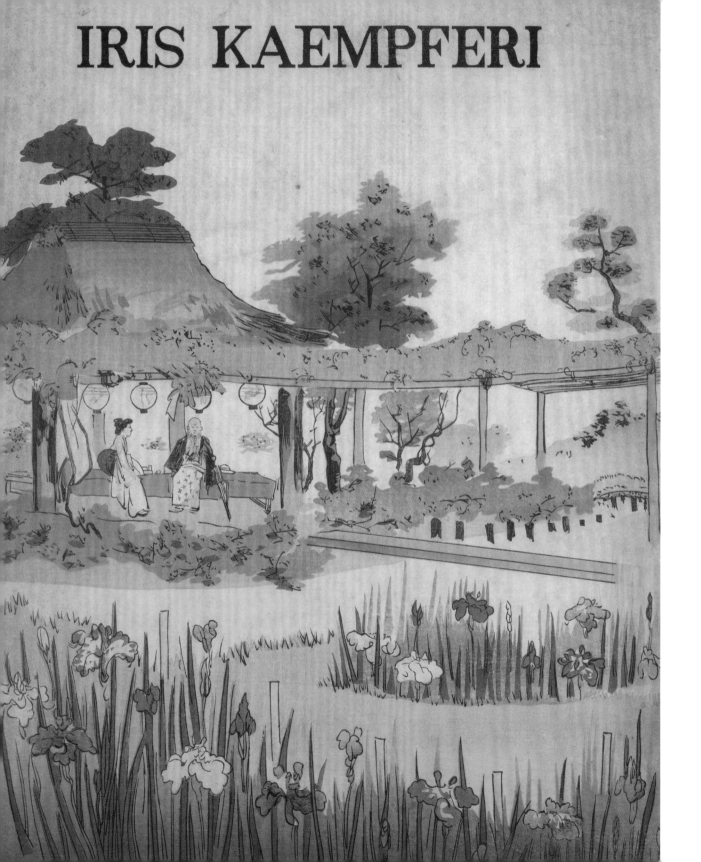

1893

Increasingly we see that, as Geraldine was usually away from Palmerstown in the summer, her greatest energy was put into buying and planting out spring bulbs, which she did by the thousand, mostly in huge drifts along the paths and under the trees, and that she watched carefully as the days lengthened and delighted in them as they began to appear and flower; hundreds of special favourites were put inside the walled garden. Outside the garden, she planted 250 yews along the edge of the upper terrace near the house, which eventually were clipped into interesting architectural shapes and formed a good visual barrier between the house and the lower terrace. She saw that this lower terrace, which was below the house down two flights of steps, had possibilities and began thinking what to do with it. The month-long trip she and Dermot made to Lapland was for her uninteresting and rather uncomfortable, but she was able to make some exquisite wild-flower paintings. Above all, through her friendship with Frederick Burbidge, the renowned English plant explorer and collector and the outstanding curator of the Botanical Gardens at Trinity College, Dublin, she met Simon Doyle – and finally, in him, she had found the man who was to be her Head Gardener for all the rest of her years at Palmerstown, and a friend until the day she died.

January 3rd — The second gate on the avenue was put up and finished by Corcoran of Naas. Snow and frost and very cold winds this month – I planted 250 yews on the Sth of the Terrace in front of the windows between the steps – having first got Anderson to move two of the big Portugal laurels, which prevented the view being seen from the drawing room. These two trees were transplanted to the Kill gate by the House.

The single yellow [*Narcissus*] Incomparabilis in the stove house are quite lovely and a great success – also [*Narcissus tazetta*] Grand Monarque and Gloriosa. These fill one side and the other side is full of Arums which are good this year.

March 7th — Obvallaris in the garden and the little [*Narcissus*] Nanus are out. Also the common Daffodil in the grass. A most wonderful spring, we have had this year. Very hot and very little rain – and now, when I am leaving this for London, **May 27th**, 1893, the Iris are nearly over, also the Day Lilies and the Poppies – and in the woods the Lilies, Laburnums and hawthorns, which all came out together, are over. The Iris border was good this year. I put a sketch of it by my father on the other side also of the little Iris graminea that grows here.

Sir Peter O'Brien took this from **15th June** to **15th September**, and we went to Lapland from which place I sent a few little plants for the rockery. I came back here on **Sept 21st** and found the garden wonderfully bright considering the extraordinary dry summer. I have bought this year the following bulbs and plants which will be put out this month and next.

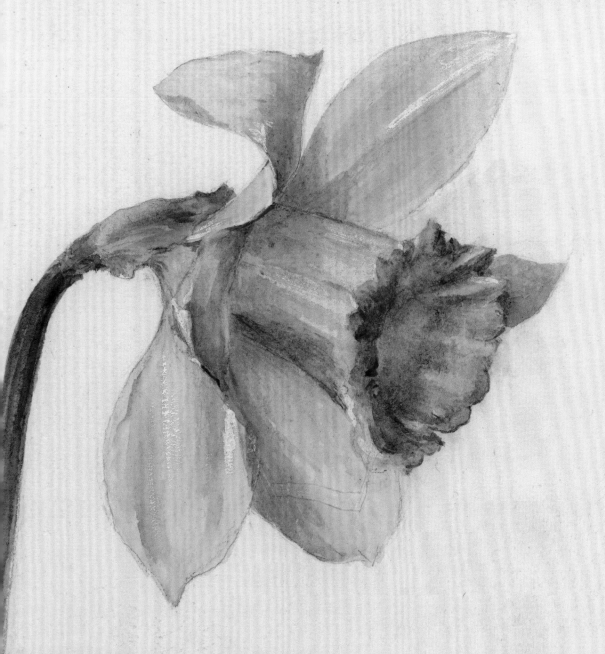

Glory of Leyden
from Scilly
15 March 1893

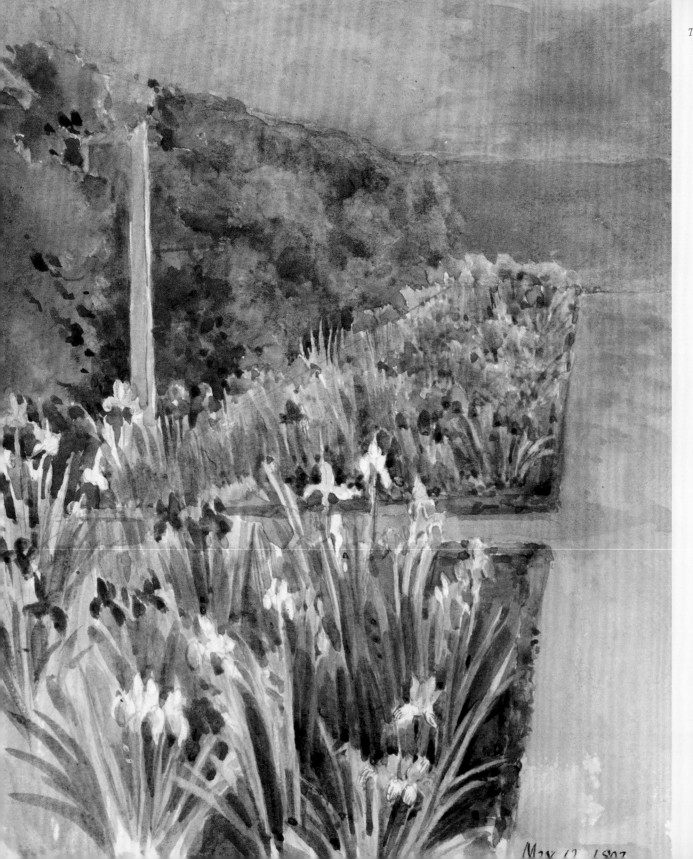

The Iris border (GP)

May 12 1897

From Jackson

~ 200 [*Narcissus*] Soleil d'Or for forcing
~ 200 [*Narcissus*] Gloriosa

From Tonkin

~ 2 doz Narcissus Ard Righ
~ 2 doz [*Narcissus*] Countess of Annesley

From Reardon

~ 300 [*Tulip*] Duc Van Tols
~ 100 Parrot Tulips
~ 17 doz named Tulips, dozens each
~ 3 doz Tulipa elegans
~ 1 doz Golden Spur Daffodil
~ 1 doz [*Narcissus*] Maximus
~ 1 doz [*Narcissus*] Muticus
~ 1 doz [*Narcissus*] Moschatus
~ 1 doz [*Narcissus*] Pallidus Praecox
~ 100 [*Narcissus*] Orange Praecox

From Army and Navy Stores

~ 4 doz Named Hyacinths for forcing
~ 600 Named Tulips
~ 200 White Crocuses
~ 100 Double Daffodils for grass
~ 100 Jonquils [*N. jonquilla*]
~ 50 The Bride Anemonies
~ 50 French Anemonies [*A. coronaria de Caen*]
~ 1 doz Rose Queen Anemonies
~ 1 doz Crown Imperial Rubra
~ 1 doz Crown Imperial Maxima
~ 1 doz Crown Imperial Crown upon Crown
~ 3 Fritillaria karelinii
~ 1 doz Fritillaria latifolia
~ 3 doz Fritillaria recurva
~ 100 Erythroniums, red white and purple

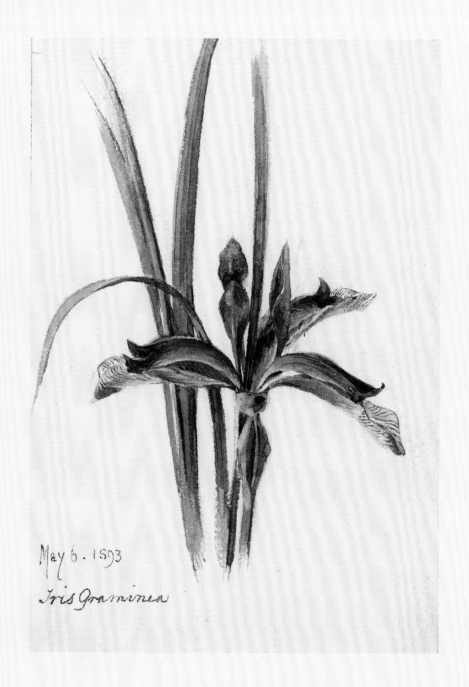

May 6. 1893

Iris Graminea

Oct 30th — A hard frost this night has killed the Dahlias and Begonias. Owing, I suppose to the very dry and hot year, the Asters have flowered wonderfully well. It has also been a wonderful year for fruit and many trees have born this year which have not done so for 5 or 6 years.

In October, Shute the gardener went away, and Doyle came, recommended to me by Mr Burbidge. He is only 24 and does not know very much I think, but he is very willing and ready to read and learn.

The poor little yews that I planted on the terrace are all dead but 9!, so I have planted them again (**Oct 24th**) and I have put a protection for them to guard them from the wind. I hope they will live now.

Oct 30th — Hard frost which killed the Dahlias.

December 30th — I picked the first Snowdrops in the garden. There is also one blue Scilla out and the Daffs are 3 inches high. The weather is too mild.

1894

This was a financial crisis year, although it's not now really clear what caused it. Dermot was quite a large landowner, with nearly 5,000 acres in Co. Kildare, 2,360 acres in Co. Meath and 559 in Co. Mayo. This was almost all good farm land which, apart from the home farm, was let out to tenant farmers. However, although the estate accounts no longer exist, there are records of Indentures that show that by this time the estate was quite heavily encumbered with mortgages and loans, all of them interest-bearing, some going back 100 years, and perhaps the costs of running Palmerstown on top of servicing these loans was too much. So, during 1894, they first let out Palmerstown to Sir Peter O'Brien (Ireland's Lord Chief Justice) for nearly 4 months, and he was followed immediately by Bob and Gertrude Connemara (Dermot's uncle and aunt), so that Geraldine only got back to see her garden in September 1895. Additionally two of her closest women friends had tragically died in their 30s (Geraldine was now 31) – Lady Dora Mina 'Miminie' Grosvenor (wife of Lord Henry Grosvenor) and Hermione Leinster (wife of Gerald, 5th Duke of Leinster). Both were considerably wealthier, and had much larger gardens with more gardeners than Geraldine, but both loved their gardens and clearly Geraldine learned much from both of them. In spite of these absences and troubles, she and Dermot had now jointly founded the Irish Arts and Crafts Society, and helped organise its first exhibition in Dublin in November 1895, which was very popular and a great success. They remained immersed in this movement for very many years, and Geraldine was considerably influenced by its gardening principles. As an extension of this, Geraldine became heavily involved in the Irish Industries Association and in this year 1894 she re-founded and became President of the Royal Irish School of Art Needlework in Dublin; all of these activities gave hand-made work to skilled women who were in need.

Feb 10th — The yellow Crocus is in full blow now in the garden. The Spring has really come – the birds are singing and all the shrubs shewing green buds. The Violets are very good. In the houses the Primulas, and Cinerarias (all white ones), are better than usual. The Hyacinths that I had got from the [*Army & Navy*] Stores are a disappointment – the Narcissus very good. The new gardener is a great improvement so far and is tidy, which Shute never was.

April 8th — The daffodils are now all nearly over. The weather has been bad for them. Such a hot sun and so much east wind with a little frost by night. They have been very good especially Golden Spur, Moschatus, Horsfieldii and Sir Watkin. The new Tulips are out too and are very good. Altogether the garden looks very well and Doyle is a great success – up to this date.

May 1st — Ideal weather, soft, sunny, with showers. The Tulips are quite lovely especially 'Rosalie' and the Gesnerianas. I have just made a hole in the garden wall, looking west and filled it with an iron grating made by Burne's son (the Blacksmith). I have taken the path up to the wall and put a seat beneath and it looks nice

The myrtles go on each side during the summer. Looking into the garden from the other side of the wall is so pretty just now when the long border of purple Iris, with double Poeticas between, are all out. The hole was made by Newman. During the winter I have employed Gill to remake the walk that goes round the place through the woods. You can now start at the lake and walk all the way round by Cullen's Lodge, past Teal's and out opposite the bull paddocks. In old days Lady Mayo/Arabella[11] used to drive round with a Postilion and an outrider. Perhaps someday I may be able to remake that part as well.

May 28th — There is still a little frost at night. The gooseberries have all fallen off the trees and most of the apricots, pears and apples. We have let this place to Sir Peter O'Brien from July 1st to October 20th 1894. I go to London tomorrow – I am sorry to say.

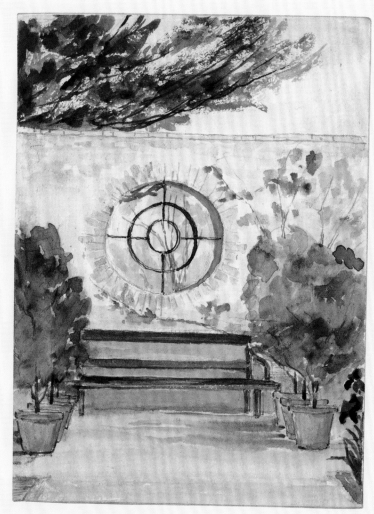

Seat and myrtles beneath the new opening in the west wall (GM)

1895

October 1st — I open this today with very different feelings to those with which I closed it, although I did not know then, that we should be obliged to let the house on for six months – this we were forced to do owing to lack of funds and Bob – Lord Connemara[12] – and his newly married wife came here on Nov 1st [*the previous year*]. We stayed in London – and it was real sorrow to me to be away. I saw the garden for a few hours in May, and again in August – and I cannot write how thankful and glad I am to be back again now. There is no such loss as the loss of 'home'. I am thankful it was only temporary. The winter they tell me was terrible – they were snowed up here for days and hunting was stopped for six weeks on end. Some things suffered – the Pittosporum on the pergola is quite killed and the Roses were all killed to the ground but have started up again. The growth since, of the trees and shrubs, is quite marvellous – and I cannot settle if it be owing to the cutting of the frost or to the hot summer that we have had – and on the whole we were very fortunate in not losing so much as many of our neighbours did, tho' some thanks I must give to Doyle for his attention to the plants under his care.

Everything in the garden has been quite satisfactorily kept by him, he is only a very young man, and to be virtually without anyone over him for 18 months is a great trial and he has come well out of it.

I must put down here the great loss that has befallen me, in the deaths of Miminie Grosvenor, and Hermione Leinster – both so fond of their garden, so interested in other people's, and so full of knowledge of the habits of plants – this latter applies more particularly perhaps of Miminie – the many flowers that they have given me are blooming now in the garden – and it will be my special care to keep them for the givers' sakes. We returned then to Palmerstown on **Sept 12th** and brought with us most glorious weather and almost tropical heat, so that the flowers have made a fresh start and are flowering freely.

October 23rd — 7° of frost last night – winter has really begun and the Dahlias and Begonias have been turned quite black. They were rather black before. We have planted some new Tulips and have re-planted the old ones – also Bazelman major and Triandrus albus are two new kinds of daffodils that I have planted besides about 200 of the old sorts. Mr Dorrien Smith sent me 100 Barrii Conspicuous. I planted today in Johnstown Wood some foxgloves from Bournemouth and some Princeps daffodils.

All the daffodils in the shrubbery at the house have been taken up and replanted. They had increased in a marvellous way. I have also filled in the little Yew hedge in front of the house. It is growing well though it is much laughed at by Dermot.

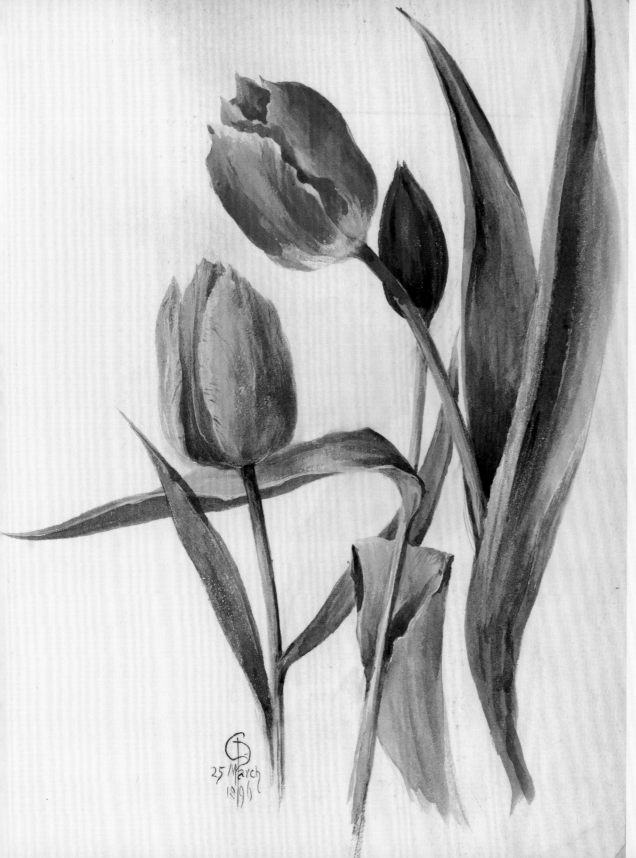

25 March
1895

Tulips 1896 (GP) 47

1896

In this year we see more than ever that Geraldine was absorbed and continuously delighted by her spring bulbs, and we can imagine her setting out each morning to visit all the areas she had planted with the thousands of bulbs she had bought, as well as the many more that came from lifting and division of her existing bulbs. These wild areas were one of the many revolutionary concepts that had been introduced by William Robinson (see page 52), whose new gardening ideas had been flowing out of his pen year after year since before 1870. Whatever she felt about his many other ideas isn't quite clear, but she certainly didn't really follow them all at Palmerstown – and when she came to visit his own garden at Gravetye Manor in Sussex in the summer of this year she realised why. She didn't like a lot of wildness inside the garden, preferring some formality, straight lines, topiary, and using massed dense planting in some places but not everywhere. She found herself 'disappointed' by this mecca of modern Arts & Crafts gardening (see pages 54–55 Arts and Crafts).

A plan of Lady Kenmare's garden at Killarney

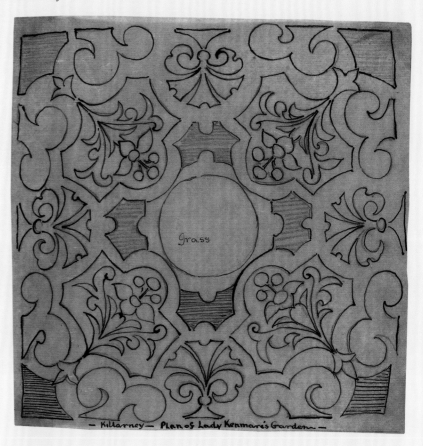

— Killarney — Plan of Lady Kenmare's Garden —

Jan 8th — On my return from Killarney, I today picked a bunch of Snowdrops which are out in the garden, also the Aconites. The Daphne mezereum is also out, and Chimonanthus fragrans [= *Ch. praecox*] has flowered this year for the first time. Lady Kenmare[13] gave me many hints and has filled me with the determination to lay out a formal garden on the lower terrace. I put here the plan of her formal garden. Mine cannot be so elaborate. She first has countless little sticks cut which she puts out according to the pattern. Then round these sticks she lays white tape – then retires to an upper window and judges of the effect. When right, the grass is dug away and evergreens planted.

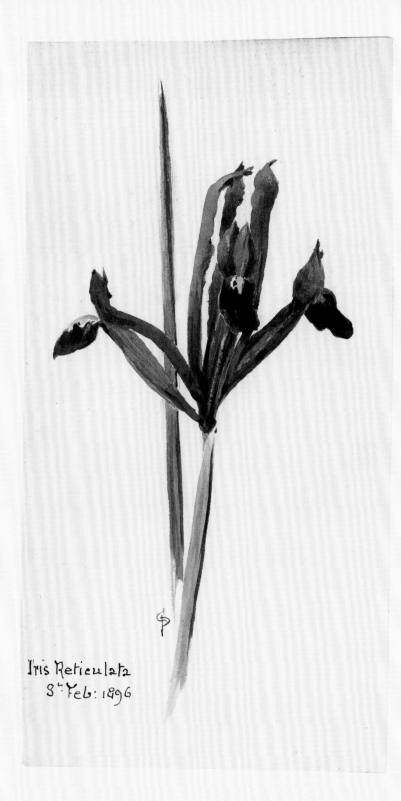

Iris Reticulata
8ᵗʰ Feb: 1896

Feb 16th — The weather is wonderful – the Snowdrops over – white and yellow Crocuses out and Scyllas, Chionodoxas, Hyacinths and Iris reticulata in full blow. It is also a wonderful year for slugs and everything has to be surrounded with wood ashes. On **Feb 12th** we picked the blue Anemone by the stream. Everything is in fact a month earlier than usual and I tremble to think what will happen if we have a frost now!

I went last week to see Mr Burbidge at the Trinity College Botanical Gardens with Clare Castletown. Narcissus Maximus and N. Ard Righ were out, also some lovely Iris, and a quantity of Hellebores. The following day we went to see Mr Moore at Glasnevin[14] and were greatly taken with Iris reticulata alba, a most lovely thing. He told me the secret of growing Freesias is to give them liquid manure when they have finished flowering, for about a month, then dry them off gently and entirely and pot again in August. On **Feb 23rd** I picked the first Daffodils i.e. Countess of Annesley – then came [*Narcissus*] Telamonius plenus on 24th, Nanus on 25th. Then we had frost, gales and rain which put the flowers back altho' Gloriosa, Soleil d'Or and Golden Spur were all out by **March 1st**. On **March 2nd** and **3rd** we had snow storms and then almost continual wet weather until **March 20th** when the weather became spring-like and everything came out with a burst.

Doyle began planting the 'M' garden [*M for Mayo*] as we call it. The 'M' was filled with Rosemary, got from Hogg and Robertson [*of Rush, Co. Dublin*]. Then box, perrywinkle, ivy and cotoneaster fill the other beds – 12 loads of manure were put in so that every chance has been given the plants. It took nearly 3 weeks to plant and Doyle was glad to be 'shut' of it. Then next, the Portugal laurels[15] (round the house terrace) have been cut in quite 18 inches for they had grown so much too big. I only trust that they will all recover for at present they look like porcupines.

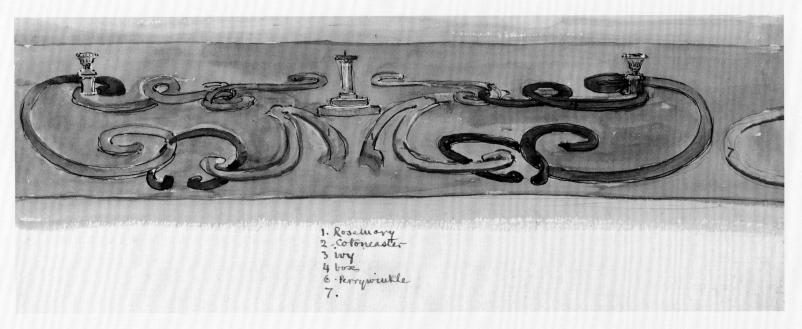

1. Rosemary
2. Cotoneaster
3. Ivy
4. box
6. Perrywinkle
7.

The design for the 'M' Garden (GM)

May 17th — We have had the most wonderful Spring – the thermometer has been at 72° most days. At the same time we had a week's frost. On **May 1st** 8° was registered in this garden, it spoilt the beauty of the Iris border and burnt up a good many things but did not do so much harm as one might expect.

The Thorns this year all over the country are a sight. I never saw such blossom and it does seem a sin to leave all the beauties of the country for London.

I did not note in this book, I think, that when Lord Wolseley left the Royal Hospital in the Autumn, he gave me his tame raven 'Jack', a most delightful bird in splendid plumage. Making the most wonderful noises, and very tame – but as the Spring came round he developed a passion for pulling up the Tulips and other bulbs as they came into bud – and this grew to such a pitch that I could stand it no longer and I have had a large aviary made for him by Doyle's house for the rest of the Spring and summer. Poor Jack, he was so angry at being put into the cage!

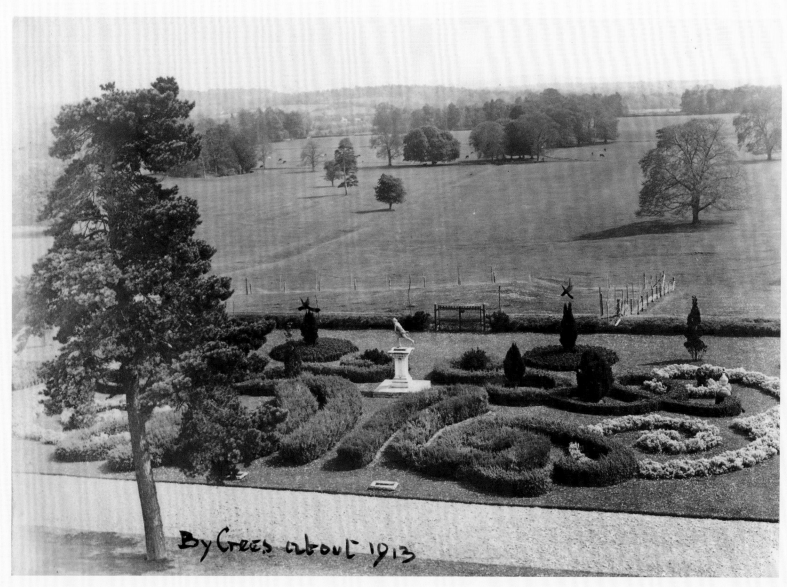

By Crees about 1913

The 'M' Garden, c 1913

Sep 11th — I returned from London and Bournemouth. The house was let to Sir James Matthew for one month. Whilst away, I went with Clare Castletown and Miss White to see Mr Robinson's garden at Gravetye. I was disappointed. There were masses of flowers of all sorts, but the arrangement is most unsatisfactory to my mind. The carnations were good and the Marliac water lilies [*Nymphaea marliacea*] quite perfect. These were of all colours – pink, red, white and yellow. Also a little paved garden was nice. Soon after, I went to see Mr Kempe's garden and that I thought quite perfection. At the entrance you find an avenue of lime trees clipped about 9' apart and the trunks bare for about 9'. At the end of these, great square red wooden tubs with clipped Portugal laurels border the path and on each side of this path you have masses of flowers and banks of clipped yew. A blue Anagallis was so pretty and also clipped Taxus japonica. Brugmansias scenting the whole garden. Then the old house, a marvel of beauty, and last but not least Mr Kempe and his dog both charming.[16]

The summer was marvellously hot and dry and a great year for Carnations. Doyle sent me over some very good ones, but now in September we are paying for it as it never ceases raining. All the Daffodil bulbs have been taken up and are now being replanted. They have increased in a wonderful way. The almond tree has fruited and the Rosemary in the 'M' garden has grown so well.

Oct 7th — I am putting a hammered iron gate that I bought of Mr Conolly of Castletown into the east side of the garden – opposite the round hole that I made a few years ago.

Dec 29th — Since Oct we had had hardly any winter; nothing but continual rain and today I picked the first Snowdrop.

*The sundial in the 'M' Garden
– Geraldine with her niece and
sister-in-law 1902*

"*This sketch, done by my father, is a view of a border of the old red Peony.*"

Through a yew hedge to a peony border, 1896 (GP)

53

ARTS & CRAFTS – A NEW GARDENING STYLE

Geraldine Mayo's Bookplate, designed by
Robert Anning Bell 1894

Most of us have never seen a proper High Victorian private garden (though there are some good re-creations like Waddesdon Manor and Hughenden Manor, both in Buckinghamshire, England), but we know more or less what they were like; we have seen their direct municipal successors in many public gardens and parks. In our minds we see edged island beds with winding paths between, often laid with coloured gravels. There are high-colour rose bushes, hollies, skimmias, cordylines, agaves and yuccas perhaps, and enveloping all this seas of bright even discordant bedded out annuals – scarlet and silvery-leaved pelargoniums, purple verbenas, hot orange zinnias, multi-coloured impatiens, shocking calceolarias, intense lobelias, and multi-hued auriculas; the plants and planting schemes will be replaced several times through the season. Dotted around will be statuary and naturalistic rock groups; a cast-iron fountain or a small cascade may be tinkling somewhere. This style of gardening went on for 40 years or more, and nothing could have been more regimented, intense and unnatural; it had brilliance but it totally lacked repose.

By the late 1860s, however, counter-currents to these over-artificial fashions ('garden-graveyards' as Robinson called them) came to the surface. William Robinson's *The Wild Garden* (1870), Forbes Watson's *Flowers and Gardens* (1872) and William Morris's *Hopes and Fears for Art* (1882) railed against the dreadfulness of this way of gardening, and pleaded for us to love plants and flowers for their individual beauty and vigour, to plant them in more natural groupings both within and without mixed borders, to train creepers and climbers up the walls, to extend the garden and to plant areas with drifts of daffodils, crocuses, etc in a semi-wild, alpine and more natural way. These new principles in horticulture, eloquently expounded by Robinson in his seminal work *The English Flower Garden* (1883) and in his two journals *The Garden* and *Gardening Illustrated* were part of a much wider movement whose principles reached into architecture, sculpture, painting, book production and almost all of the decorative arts; some of these influences are still with us and indeed these new principles in gardening have endured until today.

Inspired by John Ruskin and led by William Morris, the Arts & Crafts movement reacted violently against the machine-made, repetitive and un-aesthetic objects of the mid-Victorian period, and advocated a society that treasured craftsmen working with skill and devotion to produce objects from much more natural materials.

The first Arts & Crafts Exhibition was held in London in 1888, and both Geraldine & Dermot Mayo were active followers and proponents of the Movement. By this time Robinson's influence had almost completely destroyed the credibility of the 'pastry-cake' and 'fountain-monger's' work that had been going on in gardening and had, in a sense, allowed the Arts and Crafts Movement to spill out from the house and into the garden and its surroundings. These new concepts clearly greatly appealed to Geraldine, but she didn't carry them through to their ultimate expression. When in 1896 she went to visit Robinson's enormous garden at Gravetye Manor in Sussex she found it a little too wild, too unordered, too confused, and what she developed at Palmerstown was a Robinsonian world, but a rather more ordered one than he advocated. In this perhaps she may have been influenced by the work and writings of those other two giants of late 19th and early 20th century gardening design who followed Robinson – Gertrude Jekyll and Edwin Lutyens.

1897

Geraldine had now been working on her garden for eleven years, and you could say that her confidence was almost palpable. She entered a huge number and variety of daffodils in the Dublin RHS Spring Show, and won a prize, she was appointed President of the Naas Horticultural Society, and she started re-arranging the design and the plantings in the interior of the garden. In this year the house was let out for 5 months, and so once again she missed the whole summer and early autumn in her garden. She was mostly in England for all this time, but she and Dermot returned to Dublin in August, where they both had roles in the official visit of the Duke and Duchess of York.

Jan 15th — 12º of frost. **Jan 16th:** 18º of frost and cold and snow continued till **Feb 1st** when it began to rain and has continued to do so until **Feb 15th**.

Spring has really come and on **Feb 19th** I picked the first Daffodil on the terrace. On **Feb 21st** the first [*Narcissus*] Nanus in the garden. Scilla bifolia and Scilla sardensis [*now Chionodoxa sardensis*] are quite out and the Crocuses both white and yellow.

March 27th — We have never been without strong gales and heavy rain since this month began, and the Daffs and Crown Imperials have suffered sadly. The Daffodils are all at their best and have all come out together but are only fairly good this year owing I think to having been replanted last year. Tulip Chrysolera [*probably lost*] is out and Kaiser Kroon and others nearly so.

April 1st — I sent today the following Daffodils to the Spring Show of the Royal Horticultural Society: Class 26 for 24 varieties:

~ Emperor, Empress
~ Horsfieldii
~ Pallidus Praecox
~ Queen of Spain
~ Sir Watkin
~ Stella
~ Frank Miles
~ Golden Mary
~ Cynosure
~ C.J. Backhouse
~ Barrii Conspicuous
~ Bicolor Nelsoni
~ Rugilobus Odorous
~ O Minor Princeps
~ Obvallaris
~ Amabalis Leedsii
~ Amabalis
~ Bagelman Major
~ Grand Monarque
~ Muzart orientalis
~ Incomparablilis

In Class 27 for 12 single
varieties:
~ Emperor
~ Empress
~ Horsfieldii
~ Amabalis Leedsii
~ Barrii Conspicuous
~ Sir Watkin
~ Rugilobus odorous
~ Cynosure
~ Gloriosus
~ Soleil d'Or
~ Scilly White

In Class 40 for bunches I sent:
~ Sir Watkin
~ Emperor
~ Empress
~ Stella
~ Barrii Conspicuous
~ Odorus, and double
 Incomparabilis.

For this last I got 3rd prize –
Miss Currey[17] sent a splendid
lot and I must get more trumpet
daffs, as Tazettas are not looked
at at all.

May 12th — Just going away, leaving everything very
backward indeed.

October 12th — I returned home – we had let the house to Mr
Gardner from June 1st to October 1st. The summer has been very
wet, but the autumn fine – I find Shirley Poppies, Sweet Peas,
Roses and Michaelmas Daisies in quantities. During this month I
planted the top of the wall by the new steps, a Rose hedge behind
the limes by new Road, took up and cleaned the Iris border and
re-planted it, drained the little beds by the Round Pond and put
in new earth, planted 24 China Roses in the Currant Square,
levelled the bed by new steps and re-planted alternate beds of
Tulips and Daffodils, dug up herbaceous border opposite west
wall and replanted in small beds. The Yew hedge in front of the
house is doing well, also the M garden, the Rosemary having done
especially well. My mother sent Dermot a present of two stone
lions, (later removed to top of walls each side of Iron Gate into
garden [*where they still are*]), which she bought at Salisbury and
these are in front too. A good quantity of herbaceous things came
from Pritchard at Christchurch. These I also planted.

December 22 — Today I picked first rate Saffrano [*or Safrano*]
Roses, Xmas Roses [*Helleborus niger*] and Violets to send to Kate
Greenaway [*a friend of the Ponsonbys*] and others. The weather is
spring-like and very damp.

Dec 29th — Today I saw the first Aconites. The Snowdrops are
an inch above the ground and the Daffodils six inches. The
weather is quite hot.

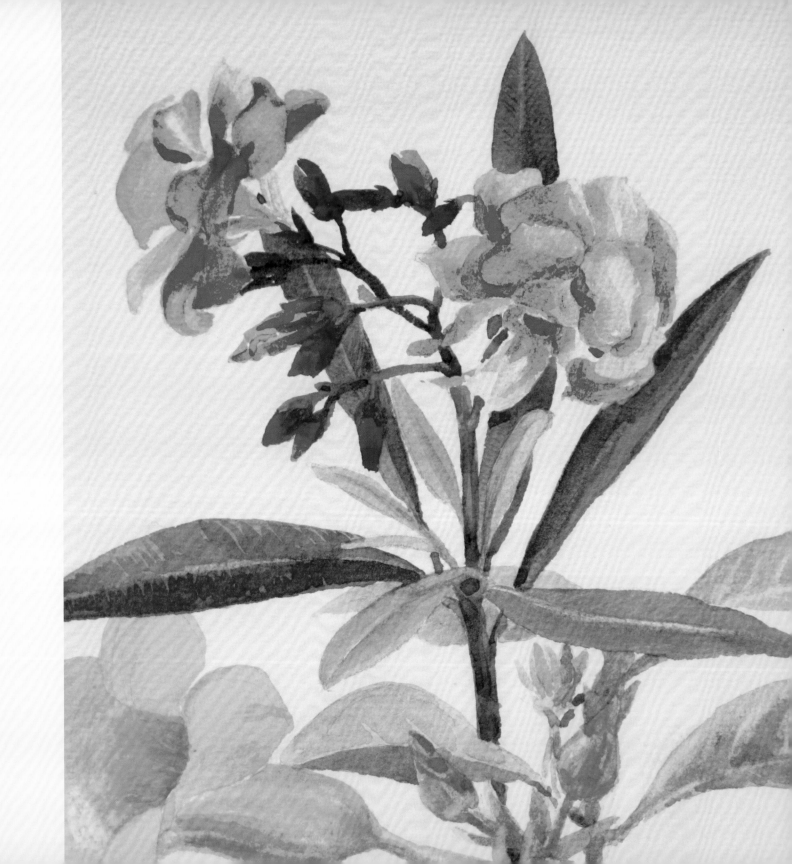

1898

Feb 1st — I picked Pallidus Praecox and Nanus Daffodils in the garden. Snowdrops are over. Daphne mesereum in full bloom. Crocuses, Scillas and Chionodoxas out. **Feb 5th —** 7° of frost last night with a blizzard of snow and sleet – everything flat on the ground! Very sad.

May 20th — I got first prize at the Dublin Horticultural Show for Daffodils but it was more on account of ours being forwarder than most, I think. The Tulips all over the county have suffered so mine are not peculiar. The only ones that have done as well as usual are the ones I bought from Lady Kennedy, which have increased and done well. I have not yet managed to get the lock put on the new gate in the garden, although ordered over a year ago! I [*have*] sewn grass seed tho' on each side of the new road from the gate and it looks so well. The limes have every one done well and the Rose hedge planted behind has grown. I leave here on the 24th as we have let this place to Mr Gardner from June 1st to Oct 1st.

Nov 24th — I returned here in the first week of October, and we have had a wonderful and summer-like Autumn and no frost until 2 nights ago when we suddenly had 10°. I have just finished uprooting all the herbaceous plants in the borders and re-planting them, the tall and bulky ones in the vine [*house*] borders, the low ones in one of the old borders, and the remaining I have filled with such low things as Peonies, Carnations, Polyantha Roses, Anemones etc etc. The effect will be much better as before the borders were far too narrow. The new walk to the new gate has been gravelled and looks so well and on each side I have planted two Yews – given me by my father and which are Irish Yews, with Golden Yew grafted on them – also 2000 new Tulips and several Double Cherries, Plums, Crab etc for spring effects. It has been splendid weather for planting; dry and warm, and as everything has been most carefully done by Doyle, I think a good reward should be reaped.

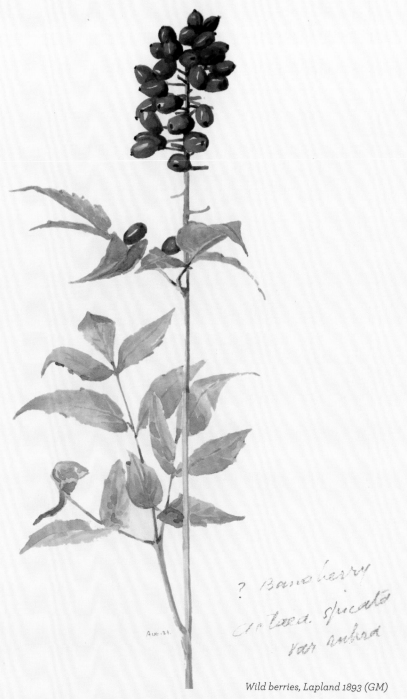

Wild berries, Lapland 1893 (GM)

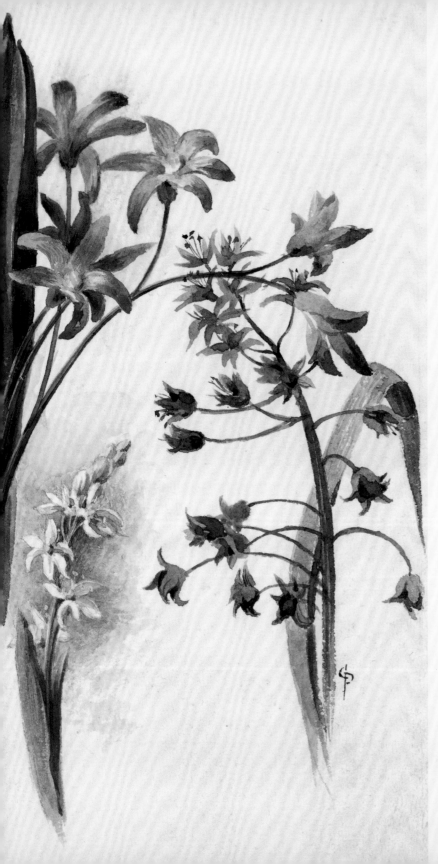

1899

Jan 15th — Since I last wrote we have had nothing but rain – floods everywhere – and warm muggy weather. The Lilies have been washed away and both here and in England never have been such gales known. We have had no frost up to this. The Aconites are just out and one Snowdrop. The Crocuses are coming up and the Scillas showing quite blue. The Tulips are up and the Daffodils too, and this continual wet must be very trying to all bulbs and great fun for the slugs. The Xmas Roses have been very good – its history is so pretty, it first bloomed in Eden where it was called the 'Rose of Affection.'

A few Scilla cretensis [*S. cretica*] are out and a few Crocus. In the houses the first Hyacinth and the Scilly Whites and Gloriosus with Obvallaris and Princeps are in full swing. The little Primula [*sinensis*] stellata is still going on – it began in Oct and is the most useful thing I ever met, as it lasts so long both in water and in pots, and is easily grown in the greenhouse.

I have just finished putting on a new roof to the Forcing pit – the old one was almost entirely rotten.

Scillas (GP)

April 6th — Today we sent two exhibits of Daffodils to the flower show in Dublin. One got a First Prize and the other a Third. They showed very well by the side of other peoples. Miss Currey sent a beautiful exhibit not for competition and Hogg and Robertson also. The Daffodils are all very good this year and began to flower about **March 10th**, with Pallidus praecox. Countess Annesley, Moschatus and Curnuus have disappeared. All the others increase and multiply. Adela [*Ponsonby, Geraldine's younger sister*] is doing a big work, in cutting out all the dead laurel round the garden wall and this is a great improvement.

The pergola is growing very well and we have put the bees out there as they were so wicked in the garden, the men could not go anywhere near them which was a decided disadvantage.

May 25th — Leaving at a most lovely time for London. The Iris are only just coming out and not a good show this year. The double Poeticas doing well, the Peonies just beginning. The new Chinese Peonies that I got from Kelway are good plants. We have put the two stone lions on the top of the wall on each side of the new gate, so now that is quite finished and the greatest improvement that we have made here. We have also taken away the fence around the gap, another great improvement. The house is let from June 1st to Oct 1st to Mr Gardner – Oh, how I do hate it.

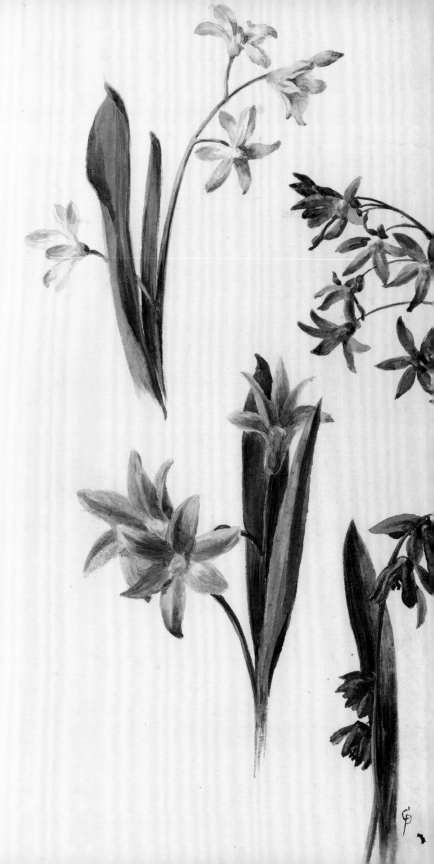

October — The weather is just like summer- so hot, sunny and dry and for a week since **Oct 16th** we have done nothing but plant bulbs and get in the spring things. I have got some good named Darwin tulips, also Tulipa sylvestris, Greigii, and Lac Van Rhyn. Otherwise, I have bought no bulbs this year, excepting a few Hyacinths as I got a good many trees and shrubs last year and find I owe a bill of £20.00 to Hogg and Robertson and so I must not be extravagant this year.

I have planted a quantity of 'Golden Mary' Narcissus (from the garden) on the terrace slope, and also white Crocus. I read the following little legend in *More Potpourri from a Surrey Garden*[18] about the Crown Imperial:

When Adam and Eve were driven from the Garden delectable, they grieved at leaving all the exquisite blossoms of Paradise behind them, and at the hardship of leaving the sunshine for a land covered with frost and snow, and then it was that pitying angels obtained permission to give them the one flower, 'The Rose of Love', as a divine token of forbearance and grace.

The Yew hedge is growing capitally and was clipped into shape this year – low in the middle with 2 steps up on each side.

Nov 11th — I have just planted 6 different Thorn trees and 1 Catalpa syriacus outside the garden by the new gate – the weather is still balmy but we have had tremendous gales and sheets of rain. The poor horses and men on the transports on their way to the war in South Africa have been very much knocked about. The Chrysanthemums, both indoors and out, have been a failure from 'Rust'[19] which is a horrible disease.

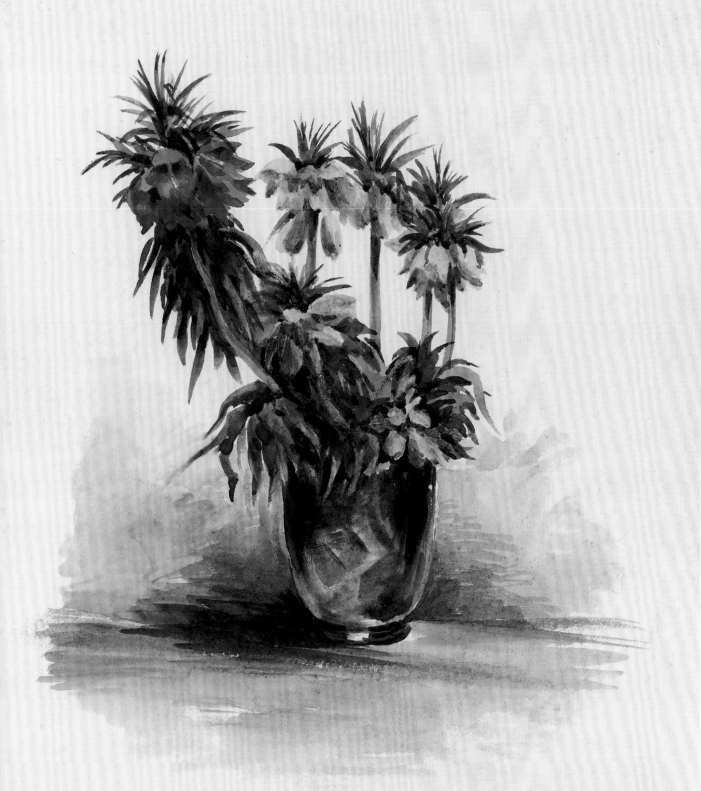

Crown Imperials (GM)

1900

This year, the first of the new century, we read that 'the garden has been for the first time a real success', a success that had of course taken 14 years of effort with up to 5 gardeners. We can't know what she was really aiming for or what she meant by a 'real success', but we can say that her expectations and standards were high. We see her taking more interest in trees and shrubs, in planting outside the walled garden, and in fruit and vegetables – even selling some of them locally. We also know that she helped a lot of local people in need, and this year we hear about her trying to help the families of the soldiers from 'The Dubs' (The Royal Dublin Fusiliers, whose home depot was at Naas), who had sailed to South Africa to fight in the 2nd Boer War.

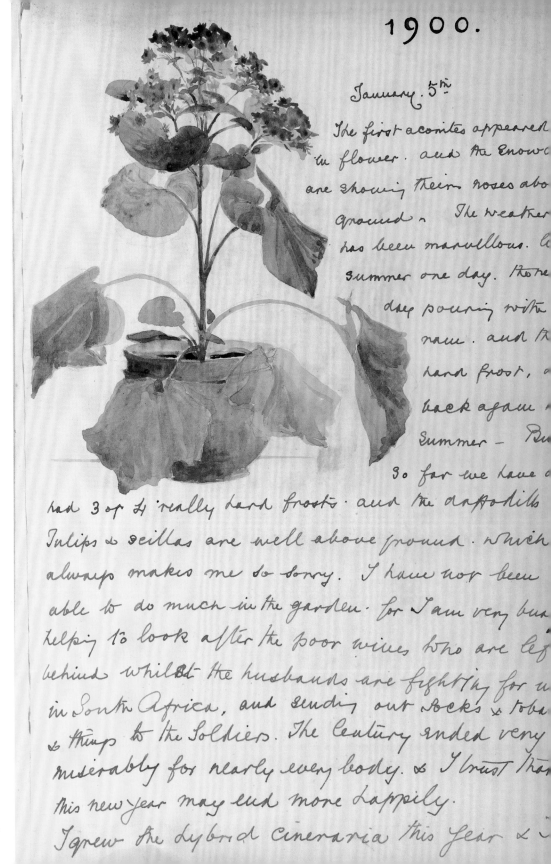

1900.

January. 5th

The first aconites appeared in flower. and the snow are showing their noses abo ground ~ The weather has been marvellous. summer one day. there day pouring with rain. and th hard frost, back again Summer — Bu So far we have had 3 of 4 really hard frosts. and the daffodils Tulips & scillas are well above ground. which always makes me so sorry. I have not been able to do much in the garden. for I am very bus helping to look after the poor wives who are lef behind whilst the husbands are fighting for u in South Africa, and sending out socks & toba & things to the soldiers. The century ended very miserably for nearly every body. & I trust tha this new year may end more happily.
I grew the hybrid cineraria this year &

Cineraria in pot (GM)

January 5th — The first Aconites appeared in flower and the snowdrops are showing their noses above ground. The weather has been marvellous, like summer one day, the next day pouring with rain, and then hard frost and then back again to summer. But so far we have only had 3 or 4 really hard frosts, and the Daffodils and Tulips and Scillas are well above ground which always makes me so sorry. I have not been able to do much in the garden for I am very busy helping to look after the poor wives who are left behind whilst the husbands are fighting for us in South Africa, and sending out socks and tobacco and things to the soldiers. The Century ended very miserably for nearly every body and I trust that this New Year may end more happily.

I grew the hybrid Cineraria this year and I think it is rather a beautiful thing. I have a very good blue one in my room now, which I have drawn here, and the foliage is fine, tho' rather lanky. I also got the pink Primula stellata, which is a fair pink, and very useful like its beautiful white sister, for the more you pick it, the better it flowers and it lasts ages in water. On the dining room table I put, on **November 20th**, some Cypripediums [*lady's-slipper orchids*], and I only took them away today, January 5th. I must get some more, for they are grand things to live in water.

Feb 15th — We have had from Feb 2nd till today, most terrible frost and snow. 22º, 20º and 18º, three nights running. The lake was frozen over, but the ice was bad. The Snowdrops, Crocuses etc were very backward, so that I trust they will not be very much hurt, but there will be a lot of deaths I fear. Now it is raining and the snow fast disappearing.

March 5th — Indoors, the houses have been most satisfactory and I have had a very good succession of pots. Nothing beats that excellent little Primula stellata, the more you pick it, the more it flowers, as I said before. The Arums have been good and we have sold a quantity at 4/6 a doz. They should pay well if grown in quantity, I think.

April 11th — The season is very late owing to tremendous frost and heavy snow which began on March 18th and lasted for a week. The Daffodils are only just beginning and there is no sign of green in the hedges – everything is a month late and the weather now is so wet and bad that I fear many things will be lost. The St Brigid Anemones, from seed given to me by Albee [*Bourke*][20], are lovely, really splendid blossoms. The Queen came to Ireland on April 4th and had a beautiful day, but otherwise it has rained almost interruptedly since.

May 16th — The garden has been for the first time a real success – it has been full of colour and the Tulips especially the new Darwins [*Darwin hybrids*] that I got from Hogg and Robertson have been quite splendid, a real joy to us – although we had gales of East winds for a fortnight or more – now it has become lovely and like the summer.

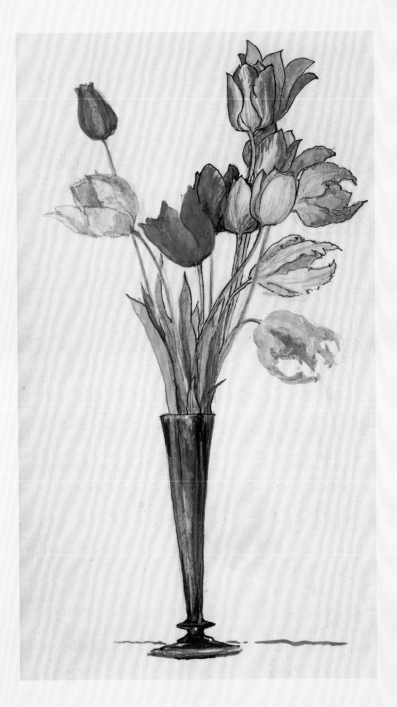

Tulips in a fluted vase (GM)

June 3rd — The Iris border is a sight worth looking at. It is quite beautiful and the ones that I got last year from Bar's are doing well. It is a great pity that we do not stay here for June, and if it were not that I have a bad attack of rheumatism, after influenza, I should now be in London.

The big herbaceous Poppies, the orange, the red and the pink, also are out and the Peonies and Clematis and Brooms make a perfect garden. The show of fruit looks well and there should be quantities this year.

September 14th — I came back here on the last day of July. Dermot has gone to Sweden to fish and we did not let the house this year – the weather seems to have been abominable and to have rained ever since I left here, and the garden looks like it for there is very little bloom and a terrible deal of leaf. The Carnations however have done really splendidly – especially the 'Duchess of Fife'. The annuals were washed away and there is no Mignonette [*Reseda*] to speak of which is a great loss. It rained more or less for the first fortnight of August and never have such floods been seen here at this time of year. After that it cleared. The herbaceous plants on the old Vine border that I planted 2 years ago were really very good indeed and the arrangement of colours very happy.

The Japanese wineberry [*Rubus phoenicolasius*] also did well and the hot sun that we are now having has done wonders to bring on the fruit.

Blue sweet pea, August 1900 (GP)

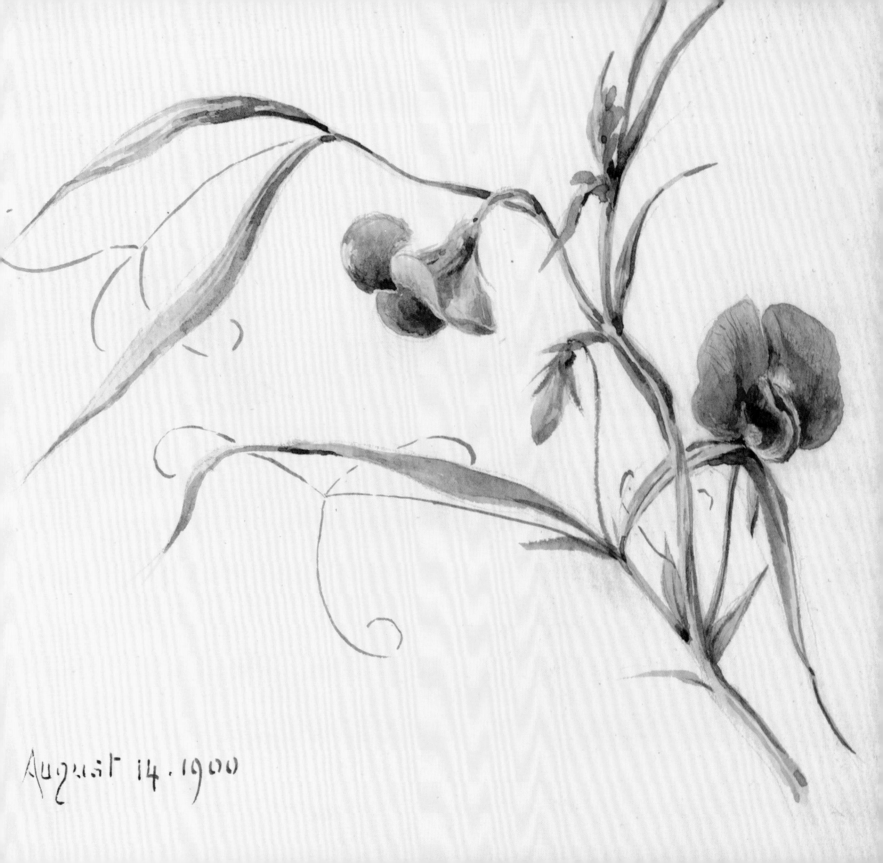

August 14. 1900

Oct 22nd — The first hard frost was last night and the Dahlias are quite black, but frost was wanted for no leaves have come down up to this. I gathered 1¼ pounds of large ripe raspberries last week and again today, a good quantity, with a dish of Scarlet runners, so that this late heat and dry weather has given us a second growth of things. All bulbs are planted now and things like Wallflowers, Arabis etc. There are quantities of apples and pears, and the peaches and grapes have done very well and have sold for quite a respectable sum. I have not bought many new bulbs this year. The following are new creepers and shrubs that I have invested in: Prunus triloba, Pyrus maulei, Staphylia colchica, Rubus rosea flore plenus [*a lost bramble-fruiting shrub*], Prunus Pisardi [*Prunus cerasifera var. pissardii*], Gentiana verna, Rubus laciniatus [*Evergreen Blackberry*], Rubus leucodermis [*Black Raspberry*].

Xmas day was a miserable day, pouring wet and storms of wind. The blue Roman Hyacinths have been delightful and they came on very quickly. The Primula stellata has also done well in the house and is the most beautiful thing at this time of year, as the more you pick it, the better it flowers and the picked flowers last quite a fortnight in water. The pink one does not seem quite so vigorous.

Wild flowers, Solfaterro (Solfatara) 1912 (GM)

1901

The year opens with Iris stylosa (I. unguicularis), the beautiful very early-flowering Iris with mauvy blue flowers that loves warm rubble and neglect, and proceeds to the difficult-to-grow double Rocket, a variety of the common Hesperis matronalis. Apart from a single day, Geraldine was again away from her garden for the whole summer and well into the autumn, as she and Dermot had gone on a month-long train journey through Belgium and Germany, lingering at the Arts & Crafts village at Darmstadt. In Belgium they bought and sent home four pyramid-shaped Bay Laurels from the famous nursery Gustave Vincke-Dujardin in Bruges.

Jan 6th — The first flower that Iris stylosa has ever given me appeared yesterday!

January 22nd, 1901 — Tonight we had the awful intelligence that the Queen was dead – it is almost impossible to believe it. The Chimonanthus [*wintersweet*] have flowered well this year though all the flowers are at the very top of the wall, which is tiresome. The Snowdrops are out but for some reason they get fewer and fewer every year since we moved them and then they were so thick, in the very same place too. The weather is horrible – it does nothing but rain and I very much fear for all the bulbs and plants; it must hurt them to be always so wet.

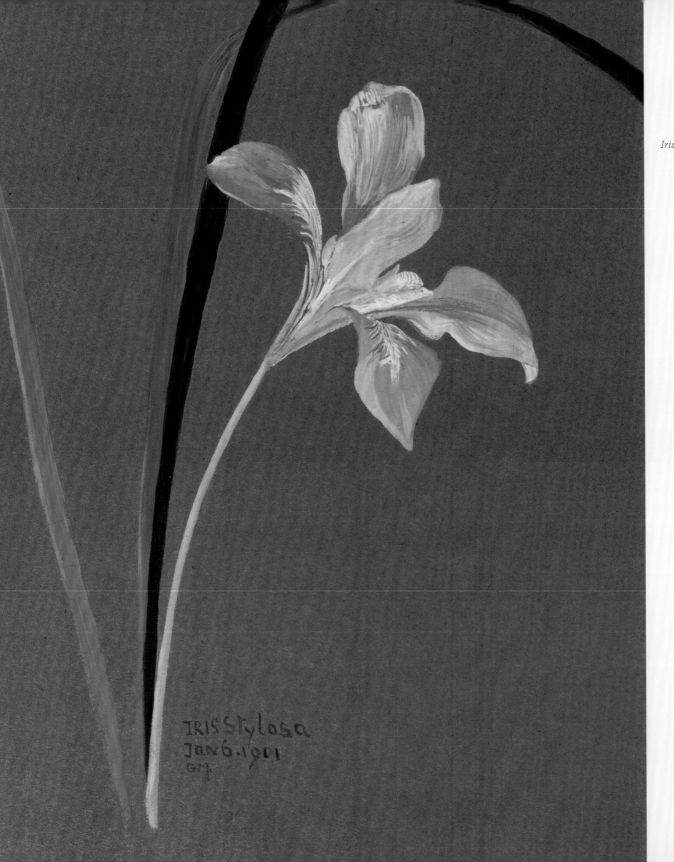

Iris stylosa, 1901 (GM)

IRIS Stylosa
Jan 6. 1901
GM

March 25th — Since this month came in we have had gales of east wind and for the last five nights 3, 6, 8, 10, and 15 degrees of frost with a snowstorm today. It is now fine and bright and we are able at last to get on with digging etc, for it is dry, but everything is very backward. The Daffodils have not begun yet, tho' a few warm days and they will burst upon us. The Scillas are out and good this year, but the dear little Nanus Daffodil that used to be with them has entirely disappeared. The Houses have done very well and I have quantities of Jonquils and Daffodils, Hyacinths etc and the Cyclamen have been most successful. This month we have employed Teele and another man to cut down and thin the trees and shrubs that have grown too much by the [*north of the*] House and we have taken out quantities of Portugal Laurels etc – and also down by the old house we have done the same.

Mr Boulton[21] has sent me a plant of the old double Rocket. I wanted this very much and I put in the extract that he sent me.

"I am afraid you will find the Rocket very small, and as I hear that it does not bear dividing over much, I am afraid your stock will be small for some time to come and that there is danger of its being lost in the huge garden at Palmerstown. I will however keep my eyes open here and will collect other plants if I can.
I hope it will prove of true pedigree. It came from Haunted Hilborough, from the manor house there, now a farm, and has no doubt been there for a century. Hilborough is one of the Shakespearean villages
Piping Pebworth, Dancing Marston,
Haunted Hilboro', Hungry Grafton,
Dudging Exhall, Papist Wixford,
Beggarly Broom and Drunken Bidford."

April 20th — The weather is fine now, and tho' there is an East wind still, the sun is very hot. The Daffodils are in full bloom and have done very well, especially those in the grass that were planted last autumn. The Tulips are beginning and this hot sun is bringing everything on.

May 26th — It has not rained since I last wrote and of course we are longing for it. The sun has been scorching and the East wind has shrivelled up most young things. Violets etc have all to be watered and it is very hard on the gardeners just now. The Tulips were beautiful, tho' the ones I got from Hogg and Robertson increased enormously in number of bulbs – but the flowers decreased. I am going to replant them this autumn; the Peonies are now out and the Iris are good.

July 30th — The house is let to Mr Gardner, but I came over for the Horticultural Show which is held here this year, and so I was able to see the garden. It is muggy and damp but the Carnations are very good and the annuals have done well. The Marguerite Carnations were very good and went on flowering until November – it was only the damp and frost that rotted them as they were still a mass of flower buds. We came home again at the end of October and I planted 2,000 Tulip Gesneriana on the terrace, in the grass, and several of the Prunus and Cerassus [*Prunus cerasus*] tribe about the place. There were a few nice climbers too on the wall at the end of the Pergola and we have stumped up the ivy that was in possession. We also had a great overhauling of the Terrace Garden and replanted the ivy beds. The Rosemary does well and grows so thick that the weeds have no chance.

1902

Geraldine enjoyed most aspects of country life – she often went out with the Kildare Hunt, and she loved tobogganing and skating on the lake. More seriously, she was now involved with numerous aspects of the Irish Home Industries, her Needlework School, various nursing charities, many local charitable endeavours, and in this year she also co-founded and was a Director of the Naas Carpet factory – an enterprise that employed numerous local people in the production of hand-made carpets. Additionally she tackled the lamentable state of the greenhouses, which were such a feature and focus of activities of Victorian and Edwardian gardens, which were now old and old-fashioned and which had almost certainly not had the annual maintenance and care that they required. It's worth noting here that Dermot was one of the 4 landlords who sat on the 1902-1903 Land Commission in Dublin which led directly to the Wyndham Land Purchase Act of 1903, called by William O'Brien 'the most important piece of legislation in Irish history'.

Wild Pansy
Malahide
April 1901 ℅

January 9th — The first Aconites were out today. How delighted one is to see them!

February 27th — In the early part of this month we had tremendous frost, 20° being the hardest. Today, however is a real spring day and the Crocuses are out and the Snowdrops and Daphne mezereum.

The frost does not seem to have done very much harm and the bulbs are coming up better than usual.

May 16th — We have had a great deal of cold east winds and frosts at night right up to this date [*May 1902 was the coldest May recorded in the British Isles in the 20th Century*] and today for the first time it is warm and genial with heavy showers. The Daffodils were particularly good this year, those in the grass on the terrace being really perfect and lasting quite two months. The Gesneriana Tulips in the grass are very fine and tho' I go through great heart breakings at finding that either rabbits or squirrels bite off the heads out of mischief, still the blaze of colour is very satisfying. Last month we put up a new sundial on the terrace made of limestone; it is rather big, but still one wants something big so near the house and I think it looks well. The Darwin Tulips have done very well again and the garden has been a great success, tho' at this moment it is in a rather untidy condition as we are putting up new greenhouses. The old ones were perfectly rotten and were beginning to sink down and these new ones that we are putting up are built on the new principle, so well adapted for our wet climate, wire tension – no wood appears outside and the galvanised steel will only require painting every ten years or so, no putty is used. The glass is clipped in and the houses are guaranteed not to leak so I hope they may be a great success.

The mistletoe in the garden that we tried to grow on the apple trees is very puzzling – some of it is growing well and then some that was started at the same time seems to be dormant. It is very slow and it will be at least 12 years before we are able to pick it!

Mistletoe. April 1902.
started by Hon: G. Ponsonby
in April 1899

I came to Palmerstown after the London Season, about **Aug 1st**. Doyle had been over to London for the Coronation which was to have taken place on June 26th but as it was postponed owing to the King's illness he did not see any of the festivities and he had to return in July.

My parents and three nieces came in August and Dermot went to Sweden. The garden looked better than at this time last year, tho' the erection of the new greenhouses had of course made a great mess – I ought to do much more with annuals, somehow I never get them in in time, I must make more of an effort this year. Commelina coelestis [*the Dayflower*] is a lovely thing, a glorious blue, but it shuts up the instant the sun is off it so it must be put into a sunny spot.

The border of herbaceous things did well and looked well but they have grown so big that I had to take a good many of them up and replant. The plants of Salvia patens did so well; I left them in the ground all last winter instead of taking them up as before and storing them for the winter. A few fir branches were put over them to protect from the hard frost and not one rotted as I was warned they would. The Lobelia cardinalis I did in the same way but it was not such a success tho' it was quite alive and flowered but not in a really healthy way. The autumn was a very wet one and very difficult to find the moment to replant bulbs and things that had been taken up. The Tulips and Daffodils were all put back into the Currant square and the Golden Mary Daffodils were thinned and put back into the same place as before. It is quite marvellous to see the way they have increased and I had two large hampers full of bulbs to plant out. These we put in the grass under the oak trees by the Ruin[22].

I also put 5,000 bluebells in the grass by Lendrums Lodge and I mean to fill this bit of the avenue now. I put more Scillas up on the terrace, planted four large round beds of box by the sundial. In January Mr Verschoyle gave me a lot of different Heaths, C[K]almias, Rhododendrons, Ghent Azaleas and other plants for a peat bed. I got two wagon loads of peat from Athy and three loads of sand from the Liffey. This was all well-mixed and put into a deep bed and so I hope the plants may do. It is by the lake at the pergola end of the walk. He also sent me many Cupressus, Cryptomerias, Benthamias and other shrubs – a delightful collection and I have planted them all myself and hope for the best.

Commelina Cœlestis
Aug:23.1902

GLASS HOUSES

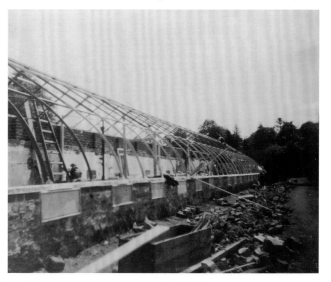

Y‌ou don't have to be a gardener to feel the magic that envelops you when you enter a glass house – whether it is a conservatory, an ornate palm house, an *orangerie*, or even a simple working greenhouse. It's a new and unreal world in which you are suspended, where you leave real life behind, where there is no breeze, no frozen soil, no puddles, no noise – where everything is calm, bright, warm and damp-smelling and usually full of interesting and unusual plants.

Buildings with large windows for over-wintering citrus trees go back a long way, and the most famous of these is the magnificent *orangerie* built at Versailles in 1685 for Louis XIV, unheated but very thermally efficient and quite warm enough to keep the orange trees in their sturdy cases happy through the winter. These houses developed enormously throughout the 18th century all round Europe, eventually acquiring glass roofs, and then finally becoming complete glass structures. In the 1840s new techniques in making wrought iron and glass led to Joseph Paxton's amazing Great Conservatory at Chatsworth, by far the largest glass building then in existence, followed by Decimus Burton's magnificent Palm House at Kew and then the giant of them all – Paxton's Crystal Palace of 1851. By this time there was a huge demand for glass houses; until about 1860 each house was still individually designed and made, but after this advances in manufacturing meant that makers were able to supply all the different elements – the iron, wood and glass – needed for a ready-made house – all the buyer had to do was to build the foundations, the floor and the low wall to support them.

Small gardens had one or two houses, larger gardens had 4, 5 or 6 and very large gardens had vast areas under glass. There were vineries with different temperature zones for growing grapes through much of the year (the roots outside the house but the branching stems within), and early and late soft fruit houses for peaches, figs and nectarines; there were carnation houses and houses to force early spring flowers, as well as houses to keep oranges and other citrus plants, and ones to preserve and bring on pot plants. There were the glass houses to produce early tomatoes, potatoes,

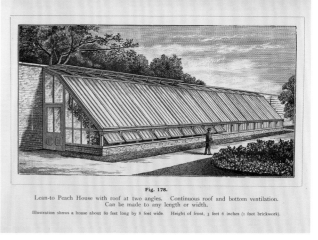

Fig. 178.
Lean-to Peach House with roof at two angles. Continuous roof and bottom ventilation.
Can be made to any length or width.
Illustration shows a house about 80 feet long by 8 feet wide. Height of front, 3 feet 6 inches (1 foot brickwork).

19th c. Peach House

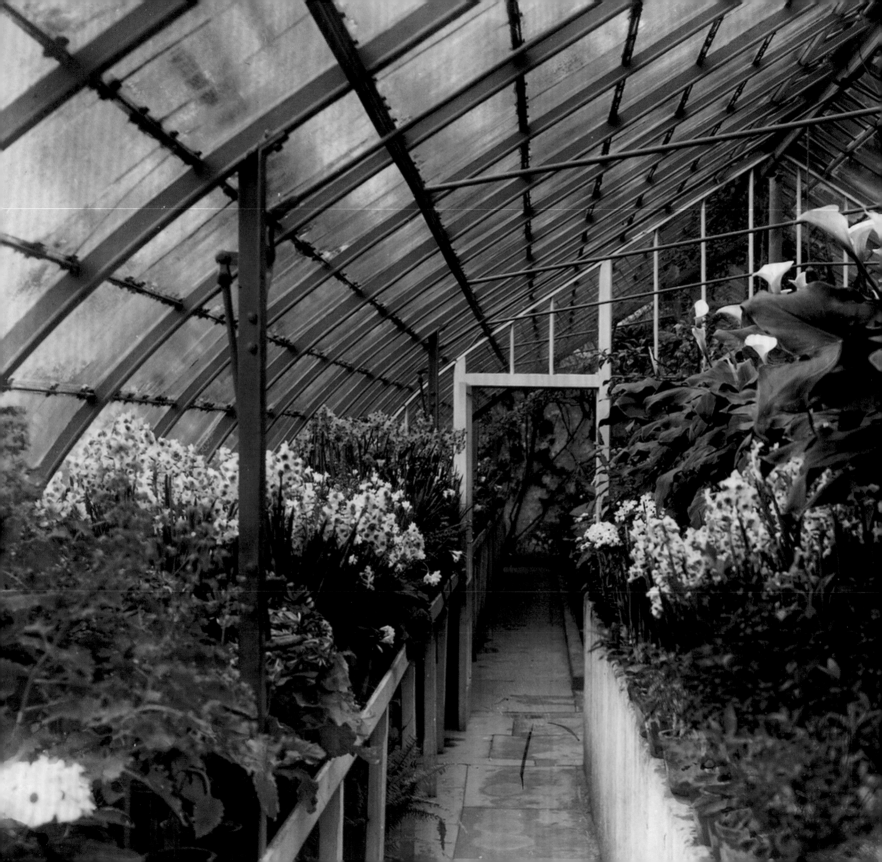

salads, houses to bring up seedlings, as well as special frame yards with pineapple pits and melon and cucumber houses. And if you were really rich and had enough staff you grew bananas, and had houses that grew exotics, palms, ferns, etc.

All of these houses operated at different temperatures, and this was made possible when the invention of hot water boilers, replacing the old stove and flue systems, allowed heat to be distributed in pipes around the site. Heating these structures was costly, noxious and arduous – the boilers had to be kept going all through the autumn, winter and spring, and that meant stoking them day and night. Additionally the maintenance – the cleaning, painting, glass and blind replacement, and the controlling of the diseases and pests that thrive in their warm damp environments (often using tobacco as a fumigant and insecticide), was very burdensome.

At Palmerstown we know from Geraldine that they had a hot house, a vinery, a stove house, a cool house, a carnation house and a peach house; there was also one or more Forcing Pits, which are glass-topped frames partly let into the ground and surrounded by fresh horse manure or fermenting oak bark which heated the soil and air inside. They all had a series of problems which she writes about.

The new 1902 greenhouse, which was about 100 yards (91 metres) long, was made of arching steel ribs, and backed onto a retaining wall on the east of the garden. On the garden (west) side, the glass came down to a low brick wall capped with stone. The boiler house and stokehole were behind the wall towards the north end.

Inside the new glass house, 1910

1903

1903 was a truly terrible year for weather. It opened with a terrible gale that was disastrous everywhere in Ireland. At Palmerstown it knocked over or broke hundreds of trees demolishing a lot of the demesne wall, it destroyed their new greenhouses, and created havoc inside and outside the garden. This dreadful gale was followed by rain – it poured for several weeks, after which there was a late Spring drought. The summer was extremely wet, and then it rained right through the autumn and froze in November. All gardeners know these sorts of abysmal years, and ask themselves despairingly whether it's really worth all the effort.

January — It has been a wretched winter and I never saw so much rain, nor the garden so damp - this latter has got so much worse of late that I decided to run a deep drain down it. This was done by one Denny Doyle who put mantraps by the new greenhouse, at the corner of the middle path under the arch, by the Round Pond and by the middle door so that at any time one can lift the covering stones and see if the drain is running and clean out the big earthen pipes. We covered the pipes with heather from Monasterevan and the drain runs with a good fall into the drain from the lake into the Stable yard just opposite the middle gate and about halfway between the gate and the little wood by the stables. This was a very big job and made an awful mess but was well worth doing.

The Vineries all had their second coat of paint or rather two coats of paint inside and are now in good condition - and we planted 5 new Peaches and 2 Nectarines in them - and also 3 Roses in the house where the [*Rose*] Marshal Neil is. There was a small house between the vineries and the peach house where 2 Nyphetos Roses were. This house was quite rotten and as it was a passage to the bothy, and contained 4 doors, it was very draughty, so I took it down and did not put it up again but built an arch here and thoroughly drained this corner. Eventually, I hope to have an opening in the garden wall beyond and see the grass and trees of the lawn, but at present the only pear - a Jersey pear - that is any good in the garden comes in the way so I do not like to take it down! The shrubs that Mr Verschoyle gave me seem all well, altho' they did get 17° of frost the day after they were planted! The new Greenhouses I am much pleased with and the bulbs have done remarkably well in them. I have today out Soleil d'Or and Golden Mary, Gloriosus, Horsfieldii and Hyacinths in quantities.

Feb 27th — Last night about 10 p.m. began the most terrific gale that has been known for 60 years or more – in fact since the great gale known as the 'Big Wind'[23]. We went to bed and said 'What a gale it is' but about 1 a.m. it was more than that. The wind was from the SW and as my room faces that way, I had the full benefit of it. I got up to see if all the windows were shut, but as I went out on to the gallery a slate came right through the glass dome as if it had been a bit of cheese and so I returned to my room! The noise was tremendous and every moment I expected to have the windows blown in – my bed even shook, most decidedly, and this went on until 3 a.m. when it got better – and I went to sleep. I dreaded to be told that the lodges and their inmates had been destroyed, as the trees are old and so close. Mercifully no lives were lost but Doyle came to me first thing almost in tears to say the havoc was awful and would I come and see. The new Greenhouses were a spectacle. The glass in the front of the two cool houses had been blown in and the whole of the backs blown out. The plants were all in a mash and with bits of glass presented a deplorable sight. All the avenues were blocked and hardly any of the trees in the Johnstown end of the Johnstown wood are standing. The big elms by Cullens Lodge are down and a great part of the demesne wall. The elms by the forge are down, the stable roof and carthorse stable roof and the hayshed have been ripped up. The place looks as if a great bombardment had taken place with slates, glass and ridge-tiles in every direction. Tremendous rain fell and is falling and there are lakes everywhere. It took a week to clear the road to Johnstown and the ruin of the trees makes one quite miserable. The Cedar, and the Redwood Cedars both down and the big old Silver Fir too. Rain fell in abundance and almost without intermission for 6 weeks, and as Naas and also Dublin were emptied of slates, the misery of the whole thing was more than one can say. The Phoenix Park has suffered terribly and whole houses have been demolished in Dublin. Slaters cannot be got quick enough and are paid £1 a day. It is no use attempting to write a full account of our losses here and the whole country is different.

April 10th — The weather for the last week has been better, at least drier, for up to this it has poured and no digging or planting of seeds could be done, but now we are getting on well. The Daffodils are all out – not so good as usual – the Tulips are also out, and the Scillas, which were good, are over. The Violets were particularly good. I got some Cerasus [*Prunus cerasus*] from Veitch, in pots and they are lovely (I have drawn a portrait of one on the other side) and the Ornithogalum arabicum [*Star of Bethlehem*] from Tunis have done well. They are lovely things.

I am so glad I did drain the garden, bore as it was at the time, for the borders already look the better for it. The plants in the peat bed are all looking well, tho' blown about a good bit.

Rubus arcticus, Lapland 1893 (GM)

Flowering cherry in pot (GM)

by the forge are down, &
the stable roof & carthorse
stable roof & the hay shed have
been ripped up. The place
looks as if a great bombardment
had taken place. with slates
glass & ridge-tiles in Every
direction — Tremendous
rain fell & is falling
& there are lakes
Everywhere —

Dermot is at Killarney
& telegraphed to me on the
28th to send to Sallins to meet him. By great
Exertions we cleared the Road to Cullens Lodge
He had also felt the gale there. but it was
Earlier, & driving home after shooting - about
7 PM. had been nearly blown over in the
waggonette, but evidently the gale was
not so bad as it was here —
It took a week to clear the road to

May — The Daffs have been good, this year especially in the grass, but the Gesneriana Tulips that were so splendid in the grass last year are very bad this, in fact only about half a dozen of them flowered. Lady Ardilaun[24] told me that they would go on flowering every year, that hers did so – I suppose her gardener renewed them every year! The Iris were very late and I did not see them before I left here on **May 23rd.** I laid down in grass the further square which had old plum and apple trees in it, which trees never bore anything but canker and moss. I intend to have a paved walk with a sundial and a seat and Lavender and China Roses and nothing else in it.

We returned after the season in London on **August 15th**. I was late as Dermot had a bad bicycle accident at Oakhill and was laid up there. It was most unfortunate as the Land Bill was just coming on in the House of Lords and he was unable to be present. The annuals have done badly, for in May and June there was no rain, and in July and August it poured without stopping! The Sweet Peas however were quite beautiful and we got 1st prize at the Naas Show with them. African Marigolds too were fine and tho' uninteresting things, make a mass of colour.

September — I planted 3,000 bluebells in Johnstown Wood near the road and many daffodils. I want to plant this avenue entirely with these bulbs. I also planted a hedge of box and yew on the edge of the sunk fence on the terrace with Lady Mayo's gate in the centre from which I want to put a bridge to enable one to get out into the Park.

The weather is terribly wet and prevents one getting on with any planting. We had 18° of frost in November and then more wet and everything is in a perfect sop. We put a new boiler into the Houses and now one fire does the whole range. It was put in by Skinner Board and cost £41. I had another set of pipes put in the 2nd house which was always so cold and damp.

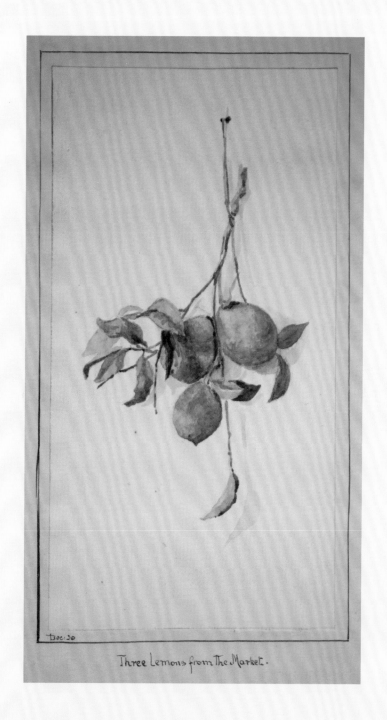

Lemons from the market in Nice, 1887 (GM)

1904

May 29th — For the last fortnight we have had summer weather – quite perfect and the garden is looking so lovely. The Tulips have been a sight this year and the Gesneriana that I planted in the grass has flowered again. Daffodils also flowered well and there is a great show of blossom and I think that now we can hardly have May frosts to destroy it. The purple Iris is out, but not the others – the common Peony is also out, and the double Poetica and Oriental poppies. I am sorry to be going to London to leave it all behind for it is very lovely this year. The Peat bed is also doing well and the Rhododendron is a mass of blossom and also the Ghent Azaleas. The wild tulip that Terence sent me from Tunis has flowered splendidly and one of the lot of Tulips sent from Nice 6 years ago has flowered for the first time.

I came back here in August and found the Sweet peas good, but other annuals had suffered a good deal from the extraordinary dry summer and also from the absence of Doyle – who, poor man, had rheumatic fever – and was ill in bed and then away taking Baths at Lucan – and tho' Kelly the foreman did his best, still the absence of the head showed itself. The double white Stock from our own seed was particularly good and the big Herbaceous border was a sight for some time. I replanted it in the Autumn as it had overgrown itself. I also planted the Carnations on a new system and a few new Tulips, otherwise lack of money this year prevented my doing very much – I put another 1000 Bluebells in near the Lodge in Johnstown Wood.

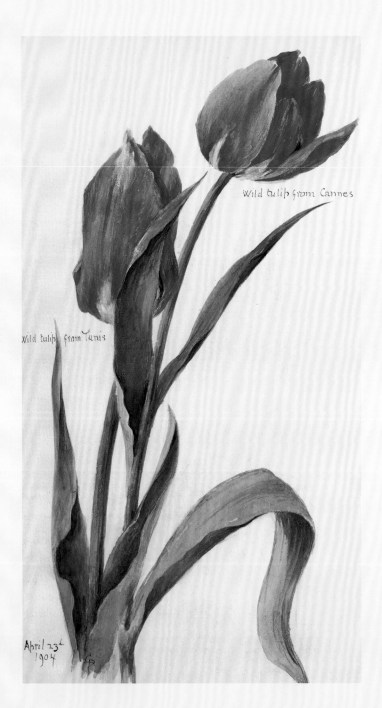

Wild tulip from Cannes

Wild tulip from Tunis

April 23ᵈ 1904

Wild tulip from Tunis and wild tulip from Cannes, 1904 (GP)

1905

1905 opened glamorously for the Mayos. Having been appointed a Knight of the Order of St Patrick, Ireland's most illustrious order of chivalry, Dermot Mayo's investiture took place in early February in a glittering ceremony in St Patrick's Hall at Dublin Castle, attended by the Prince of Wales who had come over especially for the event; there is a well-known painting of the occasion by Count Markievicz. Of course Geraldine didn't mention this in her Garden Book but, rather, delighted in her new rock garden which she had had made out of full-size rocks to replace the old small composite rockery in another part of the garden. She also created no less than 11 small herb beds interlaced with tiled paths.

Jan 11th — Mr Boulton sent me the following delightful legends

~ The Ash lent its branches for the fire on the first Xmas night and since then its beneficent quality of burning best, green, has been confirmed to it.

~ The White Campion only yields its scent at night to commemorate the hour of the Sacred Birth.

~ The Great Mullein is called the Saviour's flannel because its woolly leaves were used for the first swaddling clothes.

~ The Yellow Galleum burst into golden bloom to make an aureole about the head of the child and is still called Our Lady's bed-straw.

~ The Bracken refused the Act of Homage and has never flowered since in consequence, but if it is cut across the stem at Xmas it shows the Sacred Initial in the Greek character as a sign of penitence.

~ The Sanfoins were the holy fodder which the oxen ate in the Manger, a fact perpetuated in their name and as a reward they are blest above all other herbs of the field as food for flocks and herds.

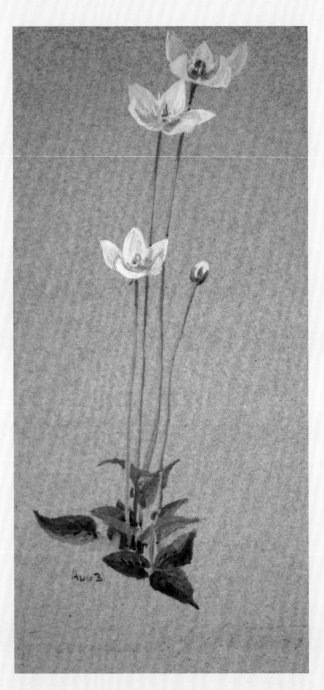

Grass of Parnassas (Parnassia palustris)
Lapland 1893 (GM)

The Rockery is going on so well. The plants have grown wonderfully, in fact so much that I have to begin to trim. I am continuing it along the back of the pit. I made this spring 11 beds for herbs with red-tiled paths between. I have Golden Thyme, Rue, Horehound, Sweet Basil, Hyssop, Borage, Lavender, Rosemary, Bergamot, and others, and the Apothecary Rose [*Rosa gallica*] hedge at the back.

May 21st — We have had the most wonderful weather and are now longing for rain. It has been and is tremendously hot and though the wind is in the East, there is not much of it.

October 25th — I returned here from London on August 5th, Dermot going off to Sweden. It has been an abnormally dry year, there having been no rain from April to July. I ran over for Ascot week and I never saw the garden look so well. The Roses were wonderful and I did not know I had any! The Carnations were not good and somehow they do not like this garden. I shall make one more effort and then leave them alone. Mrs Adair[25] gave Dermot 2 statues from Rathdair. One, Atalanta we have put on the pedestal in the middle of the [*lower*] Terrace garden – where we had intended putting a sundial, and the other, a group of a shepherd, wolf and hound, we have put at the West end of the Terrace Walk – they are very fine statues and were bought by Mr Adair and they look splendid on the Terrace. I have just finished replanting the bed up at the House – that first had ivy in and then periwinkle and neither of these did at all , it was too hot and un-shaded, and I have now put in 500 [*sic*] plants of Cotton Lavender [*Santolina*]. The Yew and Box hedge planted on the edge of the sunk fence is doing very well and it has a fence of fir branches to protect it from the wind and I shall give it this for another year and then I hope it may take care of itself. The Yew hedge on the upper Terrace has done very well and looks quite old!

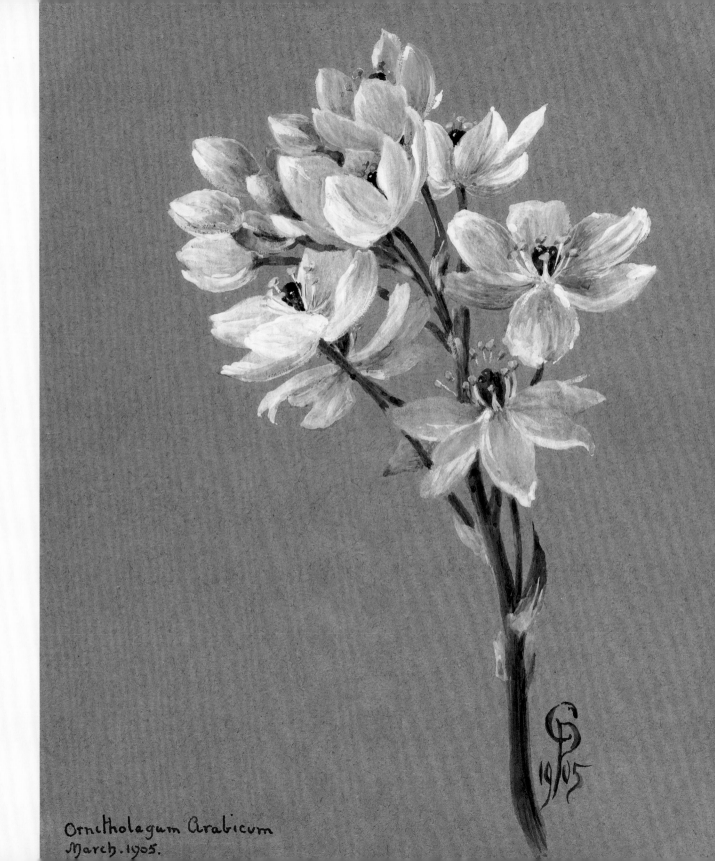

Ornithologum Arabicum
March. 1905.

1906

Jan 4th — I sent a bunch of Snowdrops, Aconites, Daphne and Chimonanthus to my father who is ill in London. They are very early this year.

Seeking a Reader's Solution

Geraldine's first entry for 1906 is January 1st and it looks like this. The Editor has failed to decipher the words that look like Fize Louise, even with expert advice. If any reader can solve this, he and the publisher would be very pleased to hear from them. Please contact them at www.lady-mayo-garden.com.

blended colour. Still to be found by those who search long enough for it in the long grass of the Maremma :—

1906.

Jan 1st. Yesterday there was a most tremendous gale from the East. & the partly rotten ash in the Fize Louise was blown down. tearing the structure, & spoiling the look of the whole thing — Fortunately the main tree was not blown down — Also the big elm on the avenue opposite the big beech tree. & about half way on the Road between the 2 White gates was broken in half. & looks horrid — I never knew such a gale. we were walking & one was quite blown along & cd hardly stand

86

May 6th — We have had a mild winter with no rain to speak of until April when we had rain, snow and frost and these have continued up to the present. The Tulips have suffered very much and the Daffodils were not so good as usual. Nor did they last so long in water. The garden has looked very well and the double-flowered Arabis has particularly been a great success and there is no doubt that it flowers better and looks better during its second year than for the first.

I came over at the end of July from London principally to see the Naas Horticultural Society's show which I had not attended before altho' I have been its President for 3 years. The Show was a good one and the Cottagers' Vegetables were first rate. I found the garden looking so well altho' the Sweet peas had not done well, owing to the extraordinarily dry summer, but the Roses were lovely and the Malmaisons [*Carnations*] very good. I went to Killarney and to Woodstock, and got back here on **Sept 17th** to find the garden nearly over. The Pink Lavatera has been and is still very good, and it is a lovely thing. Our vegetables have done well this year and we have got a great many prizes at Naas, Athy and Dublin. I had to take up the currants as they had the mite very badly. I also took up all the old Gooseberries in the square as I mean to put it down in grass. I got a few new Gooseberries and Raspberries from Veitch and also some out-door peaches which have been put on the wall by the Bothy instead of the old Jersey pears. We also took up every Tulip in the garden and replanted them and planted out by the ruin in the grass many thousands of Daffodils, the increase of about 4 years.

December 28th — 22° frost. I am employing the idle men of Kill, who suffer from want of work, to stump up the old Laurels near the garden wall.

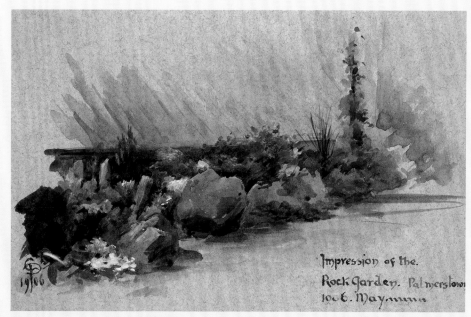

Impression of the rock garden, Palmerstown, 1906 (GP)

1907

This year Geraldine planted another several thousand daffodils, which rather than buying from a nursery she obtained by removing and planting bulb offsets from established plants. By this time after 21 years she had planted about 30,000 spring bulbs at Palmerstown, a veritable ocean of spring colour – and that is just those she recorded; doubtless there were more. She was famous for them throughout the country, and Hogg and Robinson released a Narcissus variety named 'Countess of Mayo' this year, an all yellow long cupped Trumpet, quite similar to one that her friend Lady Annesley had bred at Castlewellan, but which has since sadly gone out of cultivation. We would love to know which Hippeastrum she received from Flora Hesketh.

Tulips – Clara Butt and
The Sultan, 1907 (GP)

An alley and borders in the walled garden

Owing to my having had the influenza, I did not leave here until **June 13th** and so saw the Iris border in full beauty and it is really a sight worth seeing. I cleared out the old Gooseberry bushes from the square – they must have been 30 years old at least and I have put it down in grass. Lady Hesketh gave me about 25 Hippeastrums from Veitch and they all flowered well and are such glorious things.

I think it rained all the summer. I did not get back here until **Sept 1st.** We had lent this house to my father from **Aug 1st**, he bringing his servants, and it rained most of the time, but from the moment I came to Ireland it was quite lovely. The grass in the gooseberry square has done very well and I have put a table round one of the trees and have seats round – they look very pretty but are certainly wretched to sit on! None of the annuals did well owing to the wet but the garden in the autumn looked very well and was so late that I did not begin to dig it up early enough.

From the end of October until now – Dec – it has done nothing but pour in torrents. I never saw anything like it. We rooted up all the old apple trees and old espaliers in the fourth square with the currants and dug it quite 3 ft. deep and spread the ashes that came from burning the old roots and limed and manured the square well. It must certainly be 40 years since this square was dug up. The trees no longer bore and were covered with canker and moss that no spray would remove. I was sorry to see them go. I have broadened two borders which will be a great comfort, giving me so much more room. I planted six Lane's Prince Albert [*cooking*] apple and 6 other standards, 12 bush Apples and two Damsons – but the borders I could not plant owing to the terrible wet, so the things must take their chance heeled in for the winter. I planted some Lilac bushes outside the wall and two new beds in the Terrace garden, cut away the Veronicas from the end of the terrace which had grown so enormous and planted a Rose and 2 Crategus at these ends. We also planted several thousand Daffodils in the grass by the Johnstown Lodge – the surplus from the garden.

DAFFODILS COME
IN FROM THE WILD

As we all know, William Wordsworth and his sister were walking near the Ullswater lakeshore one day in early 1804 when they came across tens of thousands of daffodils growing in a vast ribbon down by the lake. Out of that vision came one of the most famous poems in the English language: *'I wandered lonely as a cloud / That floats on high o'er vales and hills, / When all at once I saw a crowd, / A host of golden daffodils; / Beside the lake, beneath the trees, / Fluttering and dancing in the breeze'*. Everyone then knew what a daffodil was – it was the common wild daffodil or Lent Lilly – Narcissus pseudonarcissus; even today some people call this the only true daffodil. However there were a few other old daffodil species also growing in the British Isles, notably N. poeticus – the Pheasant's Eye. From about 1840 a few keen amateurs, often clergymen (and notably William (Dean) Herbert), began to cross these two and a few other species, and started the enormous growth in available varieties which still continues to this day. Like most gardeners of the day, Geraldine had almost certainly read William Robinson's *The Wild Garden*, and she then seems to have caught the bug seriously from Algernon Dorrien-Smith who had found two unknown varieties growing out of the ruins of his Tresco Abbey in the Scillies in the 1870s, and cultivated them under the names of 'Scilly White' and 'Soleil d'Or'. But even before Dorrien-Smith the earliest and most legendary names in daffodil development had been busy: Peter Barr, plant collector and nurseryman (the Barrii daffodils) – very active in daffodil collecting and development from the 1860s until then end of his life in 1909, Edward Leeds (1802-1877), botanist and nurseryman (the Leedsii daffodils), John Horsfield, a Prestwick weaver, who bred the 'Horsfieldii' daffodil in 1845, William Backhouse (1807-1869), a north country banker who bred the Backhousei types, and Frederick Burbidge, the curator at Trinity, Dublin and a friend of Geraldine (and who in 1875 published the authoritative *The Narcissus: Its History and Culture*). Public and connoisseur excitement continued to mount; in 1884 there was held the first Daffodil Conference and William Baylor Hartland of Cork issued the first narcissus catalogue *A Little Book of Daffodils*. In 1893 the first British Daffodil Show was held in Birmingham, and new and desirable varieties were for

sale at high prices; people even went to daffodil auctions. A single bulb at that time could cost the same as you would pay today for a hundred or more bulbs. No wonder Geraldine had to spread out her purchases, but she was clearly part of a whole network of early enthusiasts for whom the narcissus was an abiding joy. The passion continued and there are today over 27,000 different narcissus species and cultivars registered with the Royal Horticultural Society – the international registration authority of the genus.

Daffodil, Countess of Annesley
(GM)

1908

June 1st — We have had a horrid winter. I think from October to February it hardly ceased raining so that I could not plant out half that I had meant to – for instance the new border from the pond to the West door that I had broadened – I have only just finished now and have painted the trellis and put gourds etc. on it as it has been impossible to plant permanently. Then on **April 2nd/3rd** we had 14º frost and heavy snow which did a great deal of harm. Since the beginning of May however we have had real summer weather and now as I am leaving it is very hot indeed and the garden full of Oriental Poppies and white Iris looks lovely.

1909

There is no Garden Book entry for this year. Geraldine and Dermot went on a 2-month boat trip from mid-March to mid-May. They travelled on a coasting cargo steamer with other passengers from Liverpool that called at the Canaries and then at ports all the way down the west coast of Africa. They stayed for 10 days in Calabar, a swampy upriver town in south eastern Nigeria. Geraldine felt the heat much more than Dermot, but she loved the vivid flowers on the shrubs and trees, and she ate avocados and mangos for the first time. On the way home they stopped for a while in the Canaries and brought home numerous cases of Canary potatoes and bananas which were all transhipped and carried back from the Dublin docks to Palmerstown on a wagon. On this trip she had a Kodak Box Brownie for the first time, and so she painted less and 'Kodaked' more. Then her beloved father became ill; she was with him very often in London where he died at the end of November.

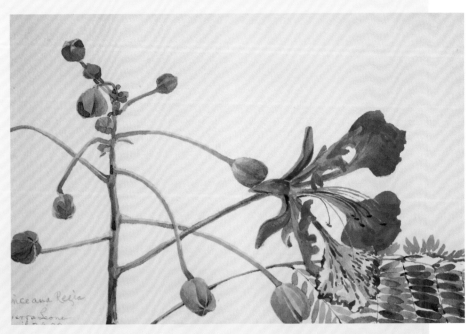

Poinciana (Delonix) regia
(Flamboyant) 1909 (GM)

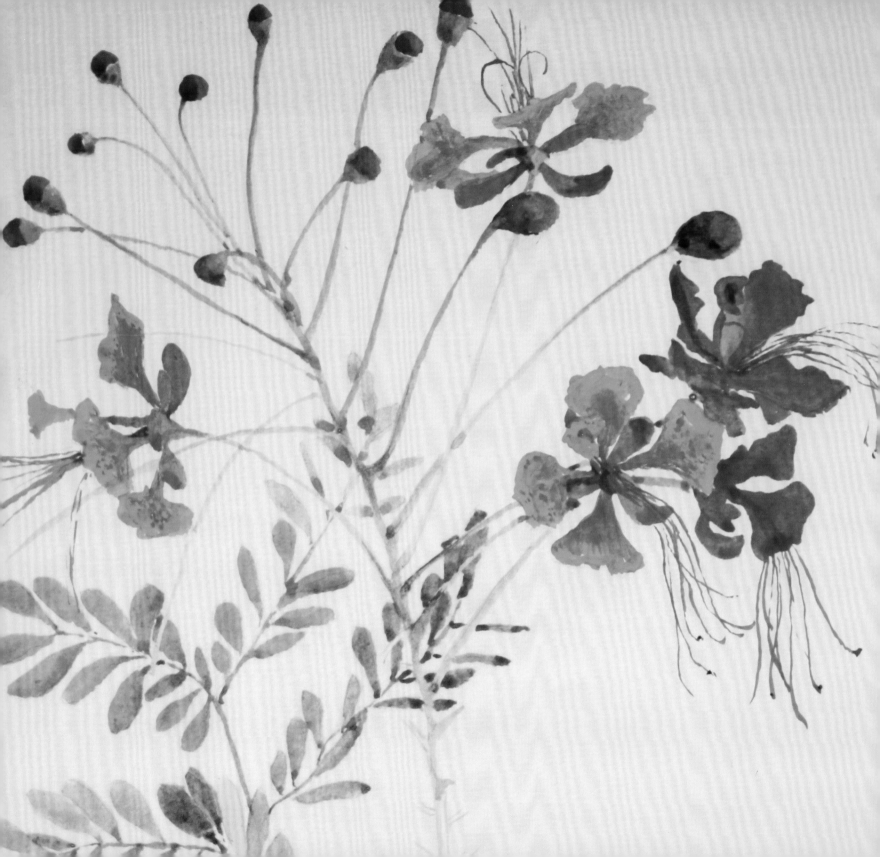

1910

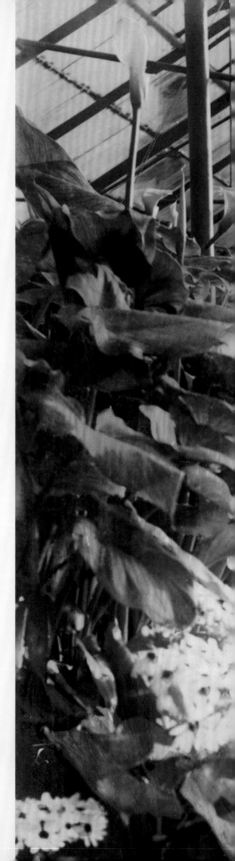

Jan 1st — On November 30th, 1908, my dear father died and I have not
had the heart to go on with this book. He was so interested in all we did
in the garden, so full of ideas as to what could be done, and most of the
drawings in this book have been done by him, that desolation fell upon
me and I could not write – but now I must begin again.

We have had a very hard winter – 20° and 27° of frost and shrubs
are beginning to show what a bad time they have had. I rearranged
the borders in the autumn, taking away some of the old espaliers
that were a mass of blight and not renewing them – by the side of the
green square. Rambler Roses on poles were planted and opposite
a hedge of red and pink China Roses – I bought some of the new
Phloxes and gave the borders a very deep digging; they were very
hard. The Sweet Peas failed and we discovered that millions of wire
worms were the cause. We are going to use Vaporite[27] to kill these
pests. The splendid old Tritomas [*Kniphofias*] are rotting away – I
fancy from old age, as they were here when I came. We have dug
them up and divided the remains and replanted them. I hope to save
a few as I never see such good ones in other gardens.

*The central path of the
walled garden, looking east.*

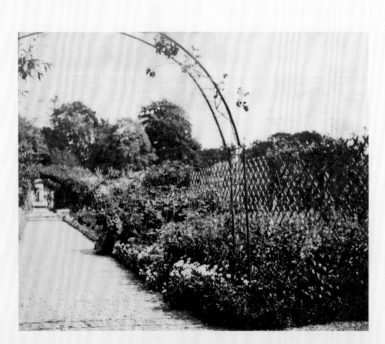

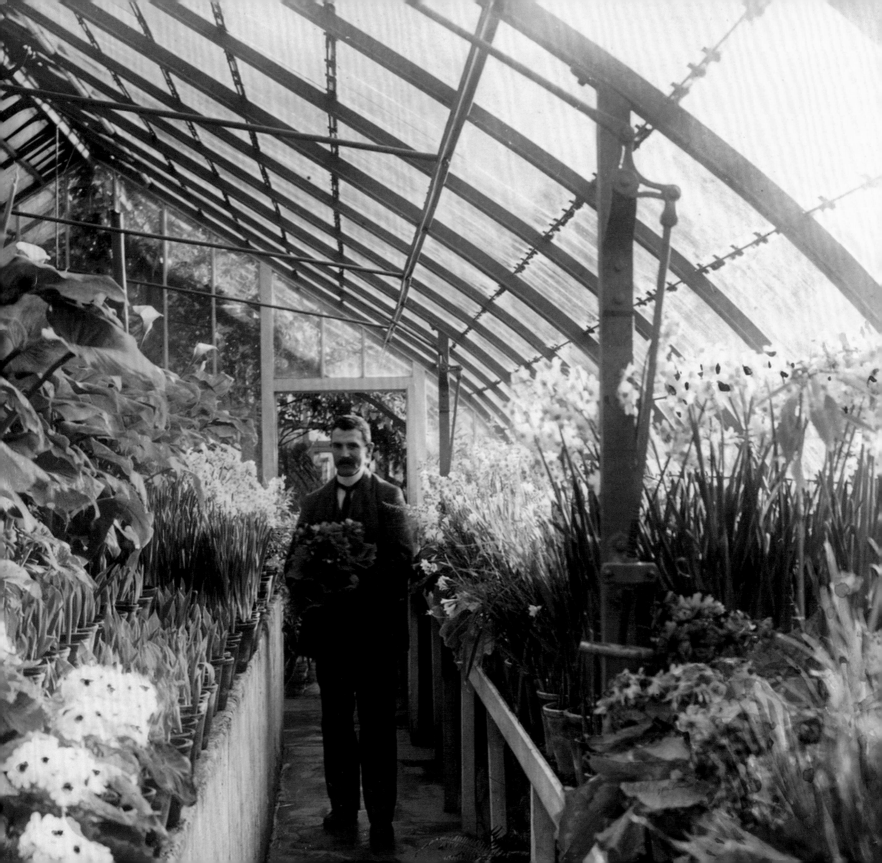

Mantelpiece, Lanusei,
Sardinia. 1887 (GM)

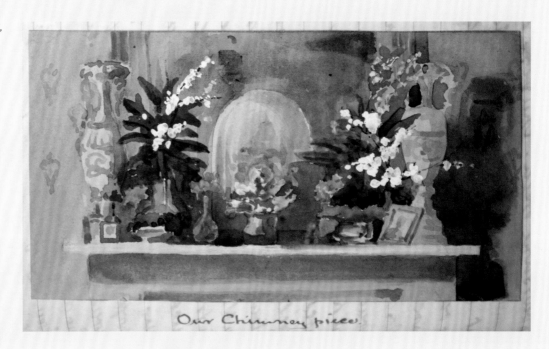

Snow began on **Jan 11th** but did not last, but on **Jan 27th** we had 18°
frost and deep snow, so that we had to use the snow plough to get
out of the gates at all. We tobogganed also but the snow was very
deep and laid on the yew hedge and did much damage for it froze so
hard, 16°, 14° and so on, that we could not get the snow off the hedge.
This lasted until **Feb 3rd** when there was a thaw but I fear a lot of
damage has been done to half-hardy things.
We had a dance here on **March 10th** and had masses of Malmaison[28]
on the supper tables. They really were lovely.

I left here on **June 1st** and returned on **Aug 16th** having been ill
and so detained in London. It has been a very wet summer and so the
garden has all gone to leaf, and is backward. It did not make any show
until September. The Chrysanthemums were good out of doors and
the Sweet Peas really splendid. I got the seed from Miss Hemus[29]. I
made a new bed on the Terrace and cleared out the dell, otherwise I
did not do very much. Planted more Daffodils under the oak trees.

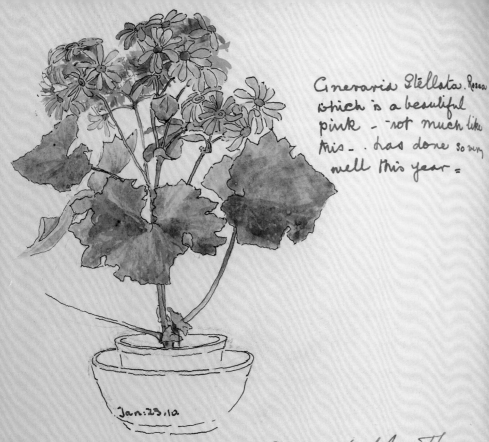

Cineraria Stellata. Rosea which is a beautiful pink - not much like this - . has done so very well this year =

Jan: 23. 10.

masses of Malmaison on the Supper tables. They really were lovely —

I left here on June 1st & returned on Aug 16th having been ill & so detained in London. It has been a very wet Summer. & so the garden has all gone to leaf. & is backward.

It did not make any show until September. The Chrysanthemums were good out of doors. The Sweet peas really splendid. I got the seed from Mintemus.

I made a new bed on the terrace & cleared out the dell. otherwise I did not do very much. Planted more daffodils under the oak trees.

Cineraria stellata rosea,
1910 (GM)

1911

From the April 2nd Census of this year we get a little snapshot of what the main household at Palmerstown consisted of at this period – the long-serving housekeeper Mary Briggs along with a cook, a butler, three housemaids, two kitchen maids and two footmen. Geraldine and two of her nieces were in residence.

The Daffodils were good this year, tho' late and the garden satisfactory. In May, Dermot and I went to the South of France where the beauty of the Judas tree is very striking. Big trees, 30 or 40 ft. high, one mass of blossom, and purple blossom too, were a striking sight. Otherwise the wild flowers were not very good (Avignon, Lyons etc we went to.)

The Coronation of King George V took place this year and the flowers were very remarkable. The summer was remarkably hot – in fact no one ever remembered so hot a time – and many things, like annuals, died from the drought, and there were numerous disappointments when we came back to the garden. At the same time, the blossom was far better than usual. I had to pull down a bit of the old vinery this autumn, as it was not safe and I built at one end a small house or pit in which I hope to grow winter flowering carnations only. I cannot put up two houses as they cost too much but I hope to do the other one next year. We had to put up a new Ram[30] this year and I can do things with a plentiful supply of water that ought to be pretty.

1912

Now in 1912, just over 2 years after her father's death, Geraldine's mother also died in London, and the only close members of her own family left were her three nieces, to whom she was very devoted. One of them, Eileen Ponsonby, went with Dermot and Geraldine to Italy for a month in the late Spring where they visited Naples, Amalfi, Ravello, etc. Again she loved and painted the wild flowers; at Ravello they visited the amazing garden of Villa Cimbroni, which she admired enormously.

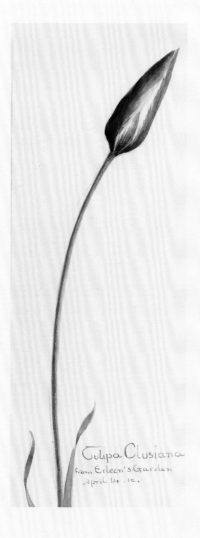

Tulipa Clusiana from Eileen's garden, 1912 (GM)

April — everything is very early. The Daffodils quite a month sooner than last year. I conclude the hot summer ripened off the bulbs early. Then we had a very wet and cold winter and spring. The brightness of Spring no longer seems the same to me for my dear mother so loved it, and she has gone from me, never to return. All the plants she gave me will be treasured, and she did delight in this place. I went to her in February and I returned in March. Eileen [*Geraldine's niece – living temporarily in the neighbourhood)* has got a very good lot of the 'Lady Tulips' or Clusiana [*Tulipa clusiana*] in her garden. It is a pretty, graceful thing.

1913

In May Geraldine and Dermot went with Flora Hesketh[31] for a month-long trip through Andalucía, travelling by railway and horse & carriage. If Geraldine was moved by Moorish gardens, she doesn't say so. This was to be Dermot and Geraldine's last trip together, though of course they didn't know that. On their return to Palmerstown they invested in two new greenhouses to replace the vinery, which had probably been in use for sixty or seventy years. These were manufactured and brought over for erection from Darlington; Geraldine was not very pleased with their look, and found the new peach house ugly.

Owing to everyone having motors in these days including ourselves, the Kill avenue is so very much more used than the Johnstown one on account of there being one gate only to open. The East side of the house and ground is not satisfactory and so I am planning a re-arrangement. In February therefore the grass was all ploughed up and the land heavily manured and potatoes planted[32]. I want to continue the lower terrace, making the East door the centre, steps down the slope opposite this door. There is an awkward corner of the sunk fence but this I think could be masked by making a paved walk out to the very corner as in Mr Orpen's rough sketch. Anyhow I shall begin and see what happens and hope for the best; the soil is wretched – principally gravel.

The Spring garden was lovely and I was loth to go away and leave it in the first week of May when we went to Spain. It was not a good year for Daffodils owing to the wet for we had a great deal of rain.

In June, Richardson of Darlington[33] finished erecting two new houses in place of the old vinery which was so rotten that it was continually dropping down. Lendrum built the walls, charging £28 and the houses were £116, in all £144 for the two – the little one being for Carnations alone, the other for peaches. I came back in August and found the garden really lovely. A blaze of colour for we have had hot dry weather here; from the end of July to **Sep 14th** we had no rain – everyone exhausted trying to water things – but it suits this damp garden. The Carnations and the Penstemons were particularly beautiful. I won the cup outright for herbaceous plants at the Naas Horticultural Show, this being the 3rd year in succession that I have done so.

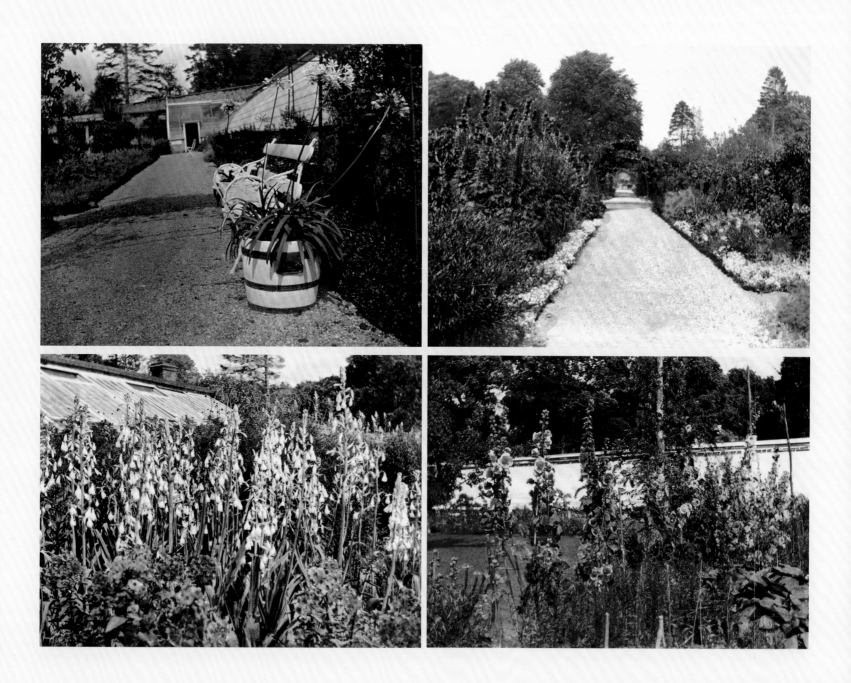

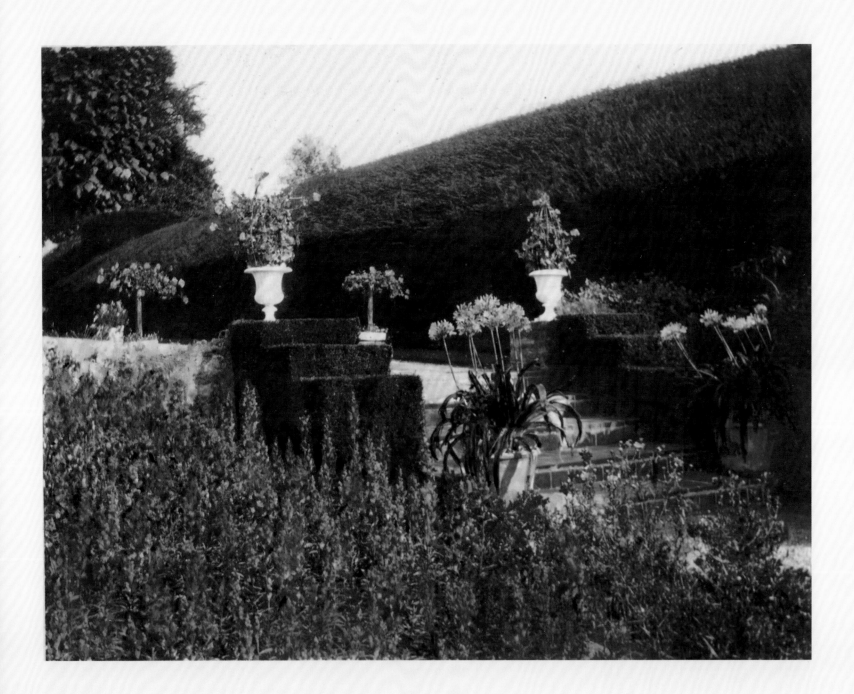

1914

1914, the year of course in which war was declared by Great Britain on Germany, the war that was to decimate an entire generation and which was to change almost everything that had gone before.

We began levelling the Terrace in February – a much bigger job than I had thought. It poured nearly the whole of February and we could not get on very much. However we finished about 70' by 20' and it was sewn with Lawn grass from Hunter's on May 9th. Later on we shall get away some more I hope – but the soil is nearly pure sand and gravel and it is difficult to know what to do with it.

I built a low wall and put in 8 iron pillars that I bought at the [*Naas*] Carpet Factory for 5/- each, to form a kind of pergola in the garden – I did this hoping to take away the ugly look of the new peach house – which is so ugly. Clematis and Vines and Honeysuckle were planted by these pillars and everyone tells me that they will not live against iron.

This photograph by Crees shows that the plants made quite a fair growth for 6 months. Another year I must have lower growing things in the beds. We had a very hot dry Aug. and Sept. but in Aug. War was declared with Germany and it was so awful that one could not think of gardens and had work to do with the soldiers' wives, Red Cross Society, that took up all one's time, also money and I bought no new plants or bulbs, nor could I go on with the Terrace, but had to leave it for better times. We had quite the worst winter I ever remember, cold and never-ceasing rain.

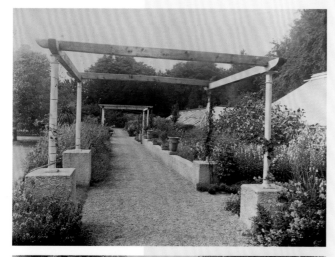

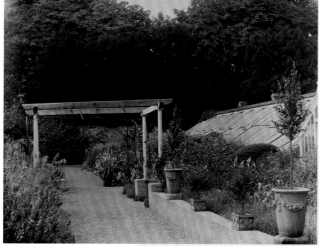

Iron pergola squares in the walled garden

1915

May — A fine Spring and the Daffodils were very good. The War still rages and there is little time to be spared for the garden. This Azalea has been beautiful and the whole house was filled with its scent.

We this year turned the bothy round, that is to say we filled up the windows that looked north and made windows and a bow window to look south – making three quite nice rooms. The summer was very wet and the garden was only fair and we are short of men and all energies expended on vegetables, supplying Hospitals and The Fleet. The Terrace is still waiting to be done and will have to wait, I am afraid.

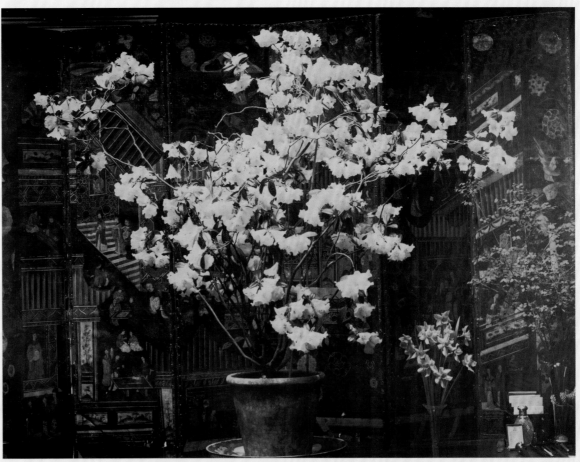

*Azalea in pot in the Great
Hall of the house*

1916

While many Irish regiments were serving in the Great War, the struggle at home by the Irish people to rid themselves of British rule now began in earnest. The Easter Rising of 1916 was followed by the War of Independence which ended with the Anglo-Irish Treaty of 1921. Many sections of Irish society rejected this and there then followed a very bloody Civil War (now often known as 'The Troubles'), with terrible consequences for the Mayos, and many other Anglo-Irish families. As this civil turmoil surrounded and affected them more and more, it's clear that Geraldine was distracted and had far less time for her garden, and, besides which, due to the war and the general unrest, she couldn't get men to work in it even though the wages had been raised.

May – the Daffodils are very good – tho' late for we have had a terrible winter of snow, rain and hard frost. The old vinery was absolutely rotten and had to be taken away. As so much glass is *de trop* in these days, we have not renewed it, but are making a pergola – using old bricks for the pillars and new "Athy" bricks for the path under it. Maurice Bevan [*husband of her niece Joan Ponsonby*] helped me very much, inventing the slate capitals for the pillars and generally planning the whole. He also made a much better plan for the Terrace and in March we made another effort to go on with it, but it poured so we had again to stop.

We replanted the new Pergola border in the autumn taking away the high growing things and also moved the Iris border – it was so full of scutch grass [*couch grass*]. The roots of scutch we sent in sacks to Lord Dunraven who has turned his tobacco factory[34] into a factory for drying medicinal herbs – most of these things used to come from Austria and Germany – we have to make them ourselves now!

1917

The weather in the early months of 1917 was absolutely dreadful in Ireland, with heavy and persistent snowfalls followed by freezing temperatures and high winds. Geraldine describes the results; many plants died, even her mock orange which is usually good at surviving cold winters in the British Isles. Worse than the plants though was the death of the vegetables, which before the War she had hardly noticed, but which now were of prime importance.

May – there are many deaths to deplore in the garden – the Choisya, Bamboos, Cordoline palms [*Cordolyne australis – the 'Cabbage tree'*] – and other friends which tho' protected, could not stand the long time of cold. Also all the Rosemary and French Lavender in the beds on the terrace are killed – and I don't think will be planted this year. Every cabbage and Brussels sprouts and all greens that we depend on were killed and they have been a very great loss in these times of food difficulties.

In Feb we planted 5 Maples on the front avenue, leading to the garden. Mrs Bourke, wife of Surgeon General Bourke who then lived in Johnstown had sent to Canada for them from her old home. They were a very long time on the road – two months or more, I think, and arrived like dead sticks. Doyle however gave them a good soaking and they recovered and are doing well. The Daffodils are not so good this year and last so short a time. They came out late and it has been very hot since **April 20th** – too hot for them. The Pergola border was a great success and did so well. We had planted a good quantity of Butter Beans and Green Flageolets – seed got from Vilmorin[35], and they did well. In October, I took all the servants down to the garden to pick them and we hung them on wires in the Peach House and the Pit to dry. Being a very damp autumn, they did not dry very well, but I then brought them by degrees to the Hall fire where I dried and podded them. It was a tiresome job, but have got several stone of them and there were useful as food – especially as there is such a shortage of ordinary commodities owing to the War. The winter was a mild one – almost too mild – and wet.

1919

Work crowded out all gardening interests and I have written nothing until now, **March 15th**, 1919 – when the Royal Dublin Fusiliers Prisoners of War in Germany are nearly all home and so my work has declined. We had the care of some 250 men and catering for them, writing to them and their relatives has really put all other things out of my head. The Armistice was signed on Nov 11th.

We had a mild winter up till Feb, when we had snow and frost – 17° most nights – and then continual rain. Everything is late – the Daffodils not out, the Xmas Roses only just over! We have had very little coal and so both last winter and this we have given up the houses in the garden and only have the Carnation house, where the furnace burns cinders and slack – but there has really been no time to think how one missed one's flowers! The difficulty of labour too has been great and at times we have only had two men in the garden, so that annuals and planting out are things of the past – beetroot and beans being grown in the borders where annuals used to be. And yet, I think that last year the garden never looked so well – the herbaceous plants were quite enough. Of course we have not yet finished the terrace – potatoes had to be grown instead!

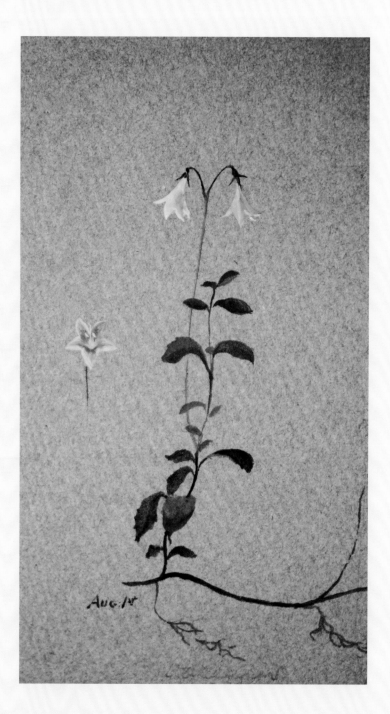

Linnaea borealis – Twinflower, Lapland 1893 (GM)

1920

1920.

May – We have had almost unceasing rain. since last Oct – a very mild winter. but very wet – I think far worse for the plants than a good hard frost. & so much has just rotted away – Even now, it pours each day. & many people have not yet got in their potatoes –

Last summer there was a strike of labourers. & for 11 weeks no one came to work – Doyle was alone in the garden ditto McKay on the Farm – & yet with the help of Carson & Hurt. they got in our hay & our coal. & the garden tho' somewhat weedy, looked as well as ever. The wages having been raised to 34/- we have to do with only 2 men in the garden. But it has taken the heart out of one. to think. old friends like Dan Connor, whom one has seen through all sorts of his joys & sorrows. should behave so badly- Cullen too. & others. I can't feel the same to them & never shall –

The daffodils have been lovely this spring – & now that I am going away. it is all looking so beautiful & only "man is vile" –

Eva gave me a pot of freesias. & they have done so well this year. I have tried to draw one. but it is an impossible colour. I find to get – They do not smell. which is their only fault. I have been able to do no improvements owing to the scarcity of labour.

Last summer there was a strike of labourers and for 11 weeks no one came to work. Doyle was alone in the garden, ditto McKay on the Farm – and yet with the help of Carson and Hurt, they got in our hay and our coal and the garden, tho' somewhat weedy, looked as well as ever. The wages having been raised to 34/- we have to do with only two men in the garden. But it has taken the heart out of one to think that old friends like Dan Connor, whom one has seen through all sorts of his joys and sorrows should behave so badly. Cullen too and others. I can't feel the same to them and never shall.

The Daffodils have been lovely this spring and now that I am going away, it is all looking so beautiful and only "man is vile". Eva gave me a pot of Freesias and they have done so well this year. I have tried to draw one. But it is an impossible colour, I find, to get. They do not smell which is their only fault. I have been able to do no improvements owing to the scarcity of labour.

Freesia (GM)

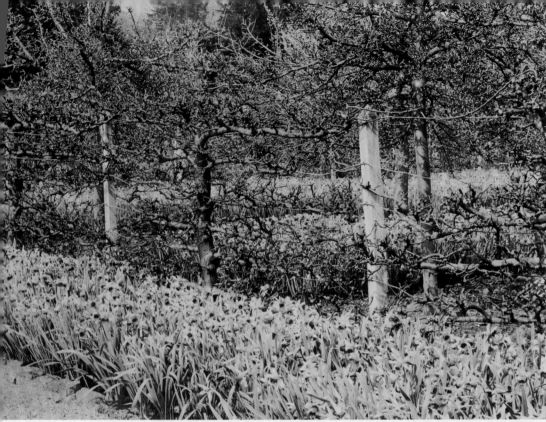

Daffodils and orchard trees

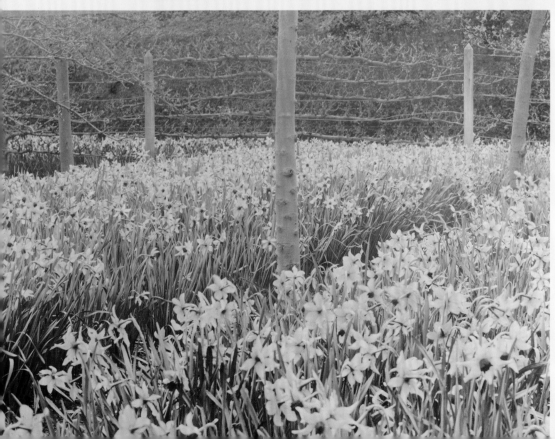

1921

In the Garden Book entries for this year Geraldine mentions the trouble and unrest in the country. These were very stern times in Ireland. There was martial law, the IRA were attacking all kinds of British and national targets as well as the army and the constabulary, and there were terrible reprisals and executions. The War of Independence was reaching its bloody peak – terror, fear and suspicion were everywhere. On May 25th the IRA occupied and burned the Customs House in Dublin, men died and tens of thousands of irreplaceable documents were destroyed.

There was a lack of manpower everywhere in the British Isles after the War, and this was to have a debilitating effect on labour-intensive gardening – the real beginning of the end of such gardens. Additionally for Geraldine, men were fearful of being seen to work at the Big Houses and their Anglo-Irish owners.

This was an extraordinary dry summer and in consequence the garden was very full of colour when I came back in Sept. We had collected the Michaelmas Daisies, and with a few new ones given by the gardener at Straffan House, and planted them altogether in the broad border in front of the Peach House. The effect was surprising – the Red one especially good – all the butterflies seemed to collect in hundreds upon this red one and it was a delight.

We have now only two men and a boy besides Doyle in the garden and so many things have to be "done without". Greenhouses are empty – and energies are spent on vegetables and keeping the weeds down! There is so much trouble and unrest in the country too that one has not the heart to care for the garden.

1922

We cleared and burned the rubbish in the Pergola wood, all trees having been cut down as they had grown so tall that the vegetable garden was completely overshadowed. The weeds are so strong that altho' we had intended to plant shrubs etc we found it necessary to wait and give it another digging over. The Daffodils were extra good this Spring and great masses of them. I came here in June for a few days for the purpose of voting at the election and found such delightful things in the garden. It is years since I was here in the summer; the Peonies being especially good.

In the spring I had to cut down two of the cypresses on the terrace (marked on the photograph) as they had grown too big. I fear some day that the others will shut out the view from the lower windows.

Peonies being especially good
In the spring I had to cut down
2 of the Cypresses on the terrace.
(marked + on the ~~drawing~~ photograph
as they had grown too big,
I fear some day that the others
will shut out the view from
the lower windows ~

Roses.

I count my hours of truest rapture those
 Passed in my garden lonely, where
 there's none
To see me stop and kiss each glorious rose,
 Breathing the purity of every one.
So close they are to God Himself, I feel
 That, kissing them, I really kiss the hem
Of His own garment, so I sometimes kneel
 And, with all reverence, I worship them.
 E. M. H.

A diary page

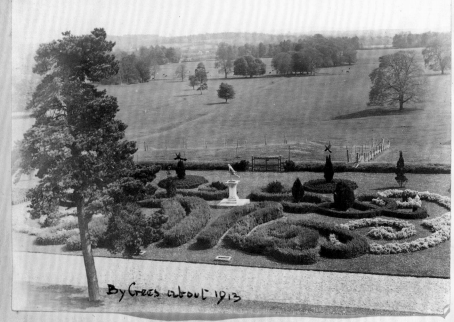

By Crees about 1913

Flower legends ~ Snowdrop ~

One day after the Fall, Eve sat weeping for the Beauties
of lost Paradise & the many lovely flowers she had
tended there & as she wept & meditated thus, an
angel was sent on earth to comfort her ~
Now since the Fall no flower had grown on the
earth, but incessantly the Snow fell & as the Angel
sweetly talked with Eve he caught a passing
flake & breathed on it & forthwith there fell
to earth a beauteous fragile flower ~
"And lo, where last his wings have swept
the snow, a quaintly fashioned ring of
milk white snow drops blow"

AFTERWARDS

Geraldine wrote not another word in her Garden Book, although after 36 years it was still only half full, and she herself would live for another 22 years. A few months after this last 1922 entry, on the night of January 29th 1923, a group of about seven armed Fenians (the anti-Treaty Republicans) came to the house, forced everyone to leave, and set fire to it. It was entirely gutted, and almost everything inside was destroyed.

The reason for the burning isn't hard to find. The Fenian Republicans were violently opposed to the Anglo-Irish Treaty of 1921/22 which established the Irish Free State within the British Commonwealth (or Empire) and, as by now they were no longer able to conduct open operations against the government, they were burning and destroying what they saw as symbols of the old Anglo-Irish ascendancy and the new breed of Irish Treaty supporters. The Big Houses were the most obvious and easiest targets and Palmerstown was one of these; additionally Dermot was a Senator in the new upper house and Senators were known and widely targeted. The fact that 6 Republicans had recently been executed in the nearby Curragh prison, though nothing to do with the Mayos, was cause enough for revenge.

Like all these burnings, it was a desperate event. Dermot and Geraldine and their household staff were given twenty minutes to evacuate the house, and in that short time some things were saved, including a number of pictures. Dermot and his groom managed to save the contents of his study, and it's presumed that among those personal belongings were this Garden Book of Geraldine and also her Travel Diaries; in his evidence as chief witness at the Court hearing nearly 3 years later, Dermot added that he had also saved 'most of my hunting clothes'. Geraldine had a very fine pearl necklace worth £5,000 (uninsured) which, it's said, she normally kept in a concealed pocket in her corset, that night however she had changed for dinner as usual and the corset was still in her room. Instead of rushing to save the necklace, she ran outside round to the back of the house to save her chickens, which were cooped under the dining room windows. The necklace and her other jewellery were never seen again. All

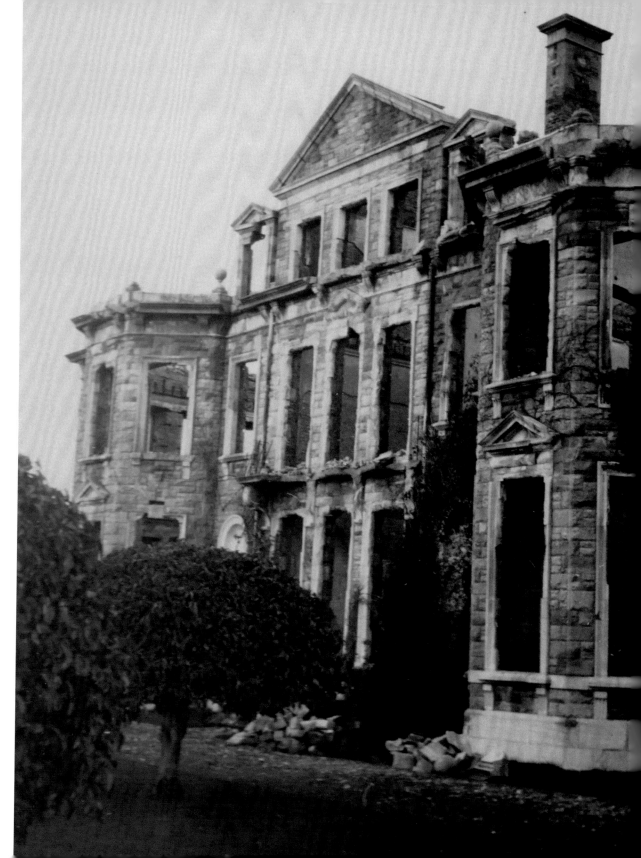

Palmerstown House, 1925, after the fire

the rest of the contents of the house were destroyed; all the remainder of the family papers and archives were lost, except for those concerning Dermot's father, the Viceroy of India, which were in the separate building at the side, and these all now form part of National Archives in Dublin, Belfast, Cambridge and London.

A new two-storey Palmerstown House was built between 1926 and 1928, but Geraldine never went back to live there, although Simon Doyle continued there as Head Gardener. Dermot died in London in December 1927, the house was let out and was eventually sold in 1946. Geraldine, who by then had lost everything she held dear, including all the members of her close family except her niece Joan Bevan (and even the Ponsonby's home at Bessborough, which was burned a month after Palmerstown), lived in London for the rest of her life, though she returned to Ireland every year. She died in London in November 1944 at the age of 81. Although the publicity in the 1930s claimed that the gardens were 'famous throughout Ireland', we have now no record of what became of them and by whom they were looked after.

Palmerstown is now a very different place. From 1956 until 2001 it was owned by the wealthy and glamorous Mrs Anne Biddle, who was the first woman in Ireland ever to breed and train thoroughbreds; she developed Palmerstown Stud into probably the largest racehorse breeding establishment in the country, and in 1966 was the first woman ever to saddle a winner in an official capacity – a horse she had trained herself. Since then much development has been done, and it is today a championship golf course with a separate club house and a venue for upmarket weddings and receptions. The walled garden is today completely abandoned, although the walls and gates still stand. Inside the grasses and weeds bend in the Kildare breeze, utterly covering all traces of the neat gravel and tile paths, the borders and beds. All the glass houses have gone, leaving ghostly white marks on the walls where they once stood, nurturing the vines, the peaches, the rows of seedlings and house plants, and the early bulbs that were brought into the house that gave Geraldine so much pleasure. It's quiet and peaceful in there, but sad, like in a cemetery. A few birds sing.

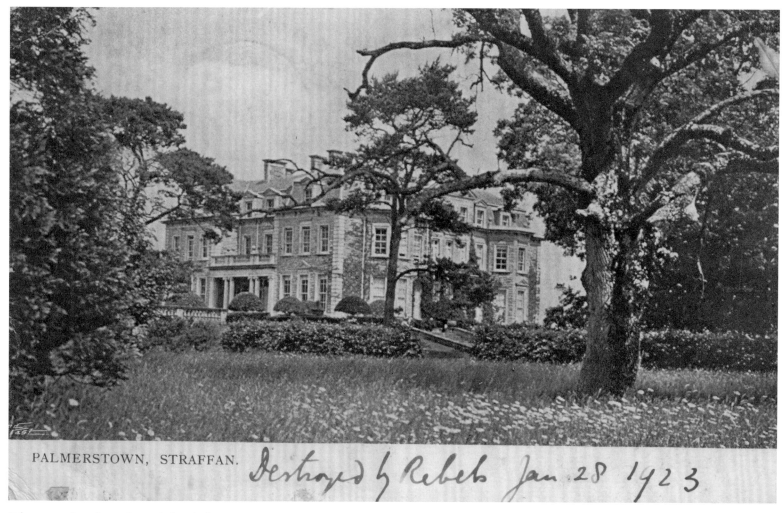

PALMERSTOWN, STRAFFAN. *Destroyed by Rebels Jan. 28 1923*

Palmerstown, from the south-west, before the fire, c 1900

ENDNOTES

1 Bessborough was a large house and estate in Kilkenny, and the ancestral home of the Irish Ponsonbys. Geraldine's father Gerald Ponsonby was a son of the 4th Earl of Bessborough, and was born and brought up there.

2 The Bourke crest is a seated erect chained mountain cat, and as her painting shows this is what she hoped to achieve on the top of her new yew hedge – a quite difficult topiary exercise.

3 Thomas Algernon Smith-Dorrien-Smith, Lord Proprietor of the Scilly Isles from 1872, a renowned gardener, spring bulb connoisseur and initiator of the Scilly flower export trade. Dermot had served with him in the 10th Royal Hussars.

4 The Mayos had a small house at Doochary, near the sea in a mountainous part of Co. Donegal, NW Ireland for very many years for fishing. They had several friends in the area.

5 Blanche, Dowager Countess of Mayo née Wyndham (1827-1918) – Geraldine's mother-in-law.

6 The Cork supplier was almost certainly the quite famous William Baylor Hartland, who had a large bulb farm there. He rediscovered and propagated several lost old self-seeding varieties of narcissus growing in Irish gardens, as well as old tulips, apples, etc.

7 Rathcoffey is an abandoned ruined mansion at Clane, north of Naas.

8 Garden produce was very regularly sent to the owners of country houses when they were away in London, usually carefully wrapped and packed into hampers.

9 The Schlossers were a German-origin Levantine family who, over several generations, had developed a thriving flower farm and bulb export business near Smyrna, Turkey.

10 James Veitch & Sons Ltd was the giant among British (& European) nursery companies throughout this period. From their huge nurseries on the King's Road in Chelsea, Exeter and Coombe Wood in Surrey. They dominated almost every department of horticultural supply, they collected and developed many new plants, and their advertisements covered pages of the gardening magazines. If you were looking for any plant, they would be your first port of call.

11 Arabella, Lady Mayo née Mackworth-Praed (1766-1843), wife of John, 4th Earl of Mayo. Lady of the Bedchamber to Queen Adelaide.

12 Robert Bourke, 1st & last Baron Connemara (1827-1902). Barrister, MP, Under-Secretary for Foreign Affairs, Governor of Madras. He married (for the 2nd time) Gertrude Coleman, a wealthy widow, in October 1894. They lived in London, but rented a succession of large houses in England and Ireland.

13 Elizabeth Kenmare née Baring, wife of Valentine Browne, 5th Earl of Kenmare, was another great friend and gardening adviser of Geraldine's. The Kenmares lived at the huge recently-built 'Jacobethan' Killarney House, Co. Kerry. The Mayos were slightly younger, and they regularly went to stay at Killarney. Valentine Kenmare, like Dermot, was later appointed a Senator.

14 (Sir) Frederick Moore followed his father as curator of The Irish National Botanic Gardens, Glasnevin, Dublin, and was there from 1879 to 1922. The influence of the two Moores on Irish and European horticulture was immense. Their cultivation of orchids was world-renowned; it's disappointing that Geraldine doesn't mention them.

15 Portugal (or Portuguese) Laurels (Prunus lusitanica) were planted all round 'new' Palmerstown, and were grown as mini trees resembling giant dark mushrooms. This was a favourite Victorian adornment.

16 Gravetye Manor, West Hoathly, Sussex, was the creation of William Robinson (1838-1935), one of the most famous of all Anglo-Irish gardeners, designers and writers, and a mecca for garden lovers. Charles Eamer Kempe, was a well-known stained glass designer & fabricator. He made an admired 'Arts and Crafts' garden at The Old Place, Lindfield, Sussex (his dog was Nora). Geraldine's reaction to these 2 gardens is significant – she disliked the 'cottagey' lush informality of Gravetye, but admired the more worked up orderly creation at The Old Place.

17 Miss Currey was most probably Frances 'Fanny' Currey, a remarkable multi-talented woman with a bulb growing business in Lismore, Co. Waterford.

18 *More Potpourri from a Surrey Garden.* Mrs C W Earle. Smith, Elder – London. 1899.

19 Chrysanthemum (brown) rust was first found in the British Isles in 1895, and caused great consternation in the horticultural world at that time.

20 Lady Albreda 'Albee' Bourke née FitzWilliam (1855-1933), the recently widowed wife of the Hon Charles Bourke, Dermot's uncle. They lived at Roseboro', a family house close to the estate.

21 William Biggs Boulton, an author and close friend of the Mayos. He collaborated on several of Dermot's own books.

22 The Ruin is an ivy-clad medieval-looking building fragment in the park between the house and the garden. Probably 18th Century.

23 The Big Wind – the legendary extreme and devastating Irish wind storm of January 1839.

24 Olivia Guinness, wife of Sir Arthur Guinness, 1st Baron Ardilaun. They had large gardens at both of their main houses – St. Anne's north of Dublin and Ashford Castle on Loch Corrib, Galway.

25 Cornelia Adair (1837-1921), widow of the legendary and very wealthy Jack Adair. They built the huge Scottish baronial Glenveagh Castle in Co. Donegal, and gradually abandoned Rathdair House in Co Laois (then Queens County). She and the Mayos were clearly close friends. The Adairs, and the subsequent owner Henry P McIlhenny, developed at Glenveagh from a barren rocky hillside one of Ireland's most remarkable and lush gardens, full of rare, tender and interesting plants, which is now at the centre of the 28,000 acre Glenveagh National Park.

26 Frederick Crees, from London, was shown as the Palmerstown Butler in the 1911 Census. As can be seen, he had somehow become an excellent photographer.

27 Vaporite was a noxious gas insecticide applied below the roots of the infected plant. The Victorians and Edwardians sprayed awful chemicals on almost everything, and this continued until the 1960s and even beyond.

28 Malmaison carnations, with an intense scent that is stronger and sweeter than all others, are hard to cultivate and very difficult to find today. They went out of fashion and have not yet come back.

29 Miss Hemus was very probably Hilda Hemus, a famous Worcestershire Sweet Pea breeder.

30 A hydraulic ram at the outflow of the lake that pumped water up to all the higher buildings and places around the garden and park. Hydraulic ram pumps, which use only the pressure of the input water to force it through pipes to a higher elevation, require no outside power and were commonly used on estates like this.

31 Florence (Flora) Lady Hesketh née Sharon (1858-1924), married to Sir Thomas Fermor-Hesketh, 7th Baronet. A great friend of the Mayos, and with whom they went on two Mediterranean sightseeing trips (1912 and 1913). Flora Hesketh was an American heiress who brought great new wealth into the Fermor-Hesketh family on her marriage.

32 Planting potatoes to help get rid of grass (especially couch grass) is an old technique. As the potatoes are earthed up, most of the remaining grass roots are brought to the surface and can be picked off.

33 Richardson of Darlington, one of the best established and most famous suppliers of upmarket heated greenhouses, vineries, conservatories, etc. of the late Victorian and Edwardian period.

34 The 4th Earl of Dunraven had recently started growing and processing tobacco at his estate at Adare, Co Limerick. Shortly after this date the factory burnt down.

35 Vilmorin, the long established seed business near Paris. They continued to supply seeds to the UK and Ireland throughout the First World War.

BIBLIOGRAPHY

There are now quite a lot of books that deal with Victorian and Edwardian gardens, and the interested reader will easily find his or her way to them. I have read quite a few of them over the years, and they have formed a background for me on this subject, but I am absolutely no expert. A few of the books that I look at and refer to again quite regularly are:

A History of British Gardening. Miles Hadfield. Hamlyn. 1969. Originally published as *Gardening in Britai'* in 1960. This is the best, the most magisterial, most perfectly researched and most engagingly written book on this subject. The bibliographical references probably form the greatest list of source references about British gardens ever compiled, certainly up to the date of publication.

The Walled Garden. Leslie Geddes-Brown. Merrell Publishers Ltd. 2007. A sweep of walled gardens from Japan to the USA, with quite a number of English ones and one Irish one. The two-page text about each garden teaches us little new, but the mostly huge and beautiful photographs certainly do. None of the most recently restored walled gardens are of course included.

The Victorian Kitchen Garden (1987) and *The Victorian Flower Garden* (1991). Jennifer Davies. BBC Books. Two of a trilogy of books that came out of, and expanded on, a trilogy of BBC Television series. Exhaustively researched and fascinatingly illustrated, they also follow the re-creation of a Victorian garden, and so cover many practical aspects, many of them now effectively lost. The bibliography gives us the names of many of the most important books that people might be reading at this time.

The Lost Gardens of Heligan. Tim Smit. Gollancz. 1997. For everybody who is interested in gardening, and especially heritage gardening, this is THE source and inspiration. Enthusiasm takes on a new meaning here.

Glass Houses. May Woods and Arete Warren. Aurum Press. 1988. The full sweep of the history of these houses, immaculately researched and beautifully illustrated, with informative excursions into American and European developments.

William Robinson. The Wild Gardener. Richard Bisgrove. Frances Lincoln. 2008.

Anyone who is really interested in Victorian and Edwardian gardening simply has to have access to *The Gardener's Assistant* by Robert Thomson. Blackie & Son. 1859 and many subsequent editions. This has detailed instructions on almost every aspect of making, planting and maintaining a garden of the period.

WALLED GARDENS TO VISIT

By the 1950s most old walled gardens had fallen into neglect, had been turned into market gardens or had been redeveloped. That situation persisted for decades. Yet now, year after year, more and more walled gardens are being restored; if you are open to the public and have a walled garden, it's almost *de rigueur*. Everyone will have their favourites. Some of the restored walled gardens that I would visit again are:

Ireland
Kylemore Abbey, Connemara. A 6-acre walled garden in a most romantic and wild place, exquisitely restored to a fully functioning Big House garden, and complete with new glass houses. There is plenty of interest for everyone in this wonderful place, which re-opened in 1999, and which seems to be improving all the time.

Phoenix Park, Dublin. A 2 ½ -acre fully restored working garden, growing a huge variety of old fruit and vegetables, along with some flowers. Very interesting to see.

Ardgillan Castle, Balbriggan, Co Fingal. A linked series of old walled gardens have been restored, and while the planting is more modern, the ensemble is very interesting and satisfying.

Bangor Castle walled garden, Co Down, N. Ireland. 1 ½ acres of very ambitious restoration, producing lots of old-fashioned flowers, fruit and vegetables. Slightly municipal with a few modern takes, but a fascinating achievement.

UK
There are now almost more restored walled gardens in the UK than it's possible to visit. A few of the outstanding ones are:

Heligan, Pentewan, Cornwall. A very large series of old gardens, rediscovered and exquisitely restored in the 1990s, Heligan, a garden that gradually fell asleep and got covered over, is the mecca and inspirational grand-daddy for absolutely everyone interested in old gardens.

Audley End, Saffron Walden, Essex. One of a series of gardens at this magnificent property that has been fully restored and is now as completely productive as it was in its heyday. An inspirational and organic place, including among other things a lovely vinery.

Down House, Downe, Kent. This is Charles Darwin's house restored to what it was in the 1840s-1880s. The walled garden has been restored and grows many of the plants that he was interested in and experimented on. A true step back in time.

West Dean, Chichester, West Sussex. A beautifully restored and fully productive Victorian walled garden with magnificent glass houses, part of a whole series of gardens and very pleasing walks.

Highgrove, Tetbury, Gloucestershire. An organic vegetable walled garden. Like everything Prince Charles and his team have done there, it is not an exact restoration, but it's better.

Osborne, Isle of Wight. A completely re-born 1-acre old flower and fruit walled garden, brimming with life and colour, some of it re-creating what Victoria and Albert saw, some a very good modern take on an old theme. Extremely interesting and educational; good glass houses. Another big success of English Heritage.

Houghton Hall, King's Lynn, Norfolk. To my mind a really fantastic restored, re-themed, re-thought, re-imagined and beautiful 5-acre walled garden. It can only be called an ornamental garden, but it has a beautiful double mixed border, a huge rose parterre, it grows fruit and veg, it has lovely greenhouses, fountains and much else besides. A unique development and worth every mile of the trip to enjoy it.

Holkham Hall, Wells-next-the Sea, Norfolk. This restored 6 ½ acre walled garden isn't everyone's idea of heritage gardening, with a plant centre, etc in the middle of it. However flowers and vegetables are grown on some scale, and its great interest is in the very numerous old glass houses, pit-houses, vinery etc., which bring back to life all that aspect of Big House gardening activity.

Rousham House, near Oxford. Going to Rousham to visit one of Britain's earliest, most lovely and most unaltered 18th-century landscape gardens you can be equally stunned by the walled gardens. Seriously beautiful old-fashioned double herbaceous borders, old espaliered apples, a charming un-fussy vegetable area and, perhaps best of all, a formal 17th-century garden of patterned box and roses with a huge old pigeon house. This garden doesn't need a new purpose – it's never lost its old one.

INDEX

Figures in italics refer to captions